ON MODERN BEAUTY

THREE PAINTINGS B

MANET

GAUGUIN AND

CÉZANNE

RICHARD R. BRETTELL

THE J. PAUL GETTY MUSEUM, LOS ANGELES

Published by the J. Paul Getty Museum, Los Angeles
Getty Publications
1200 Getty Center Drive, Suite 500
Los Angeles, California 90049-1682
www.getty.edu/publications

Nola Butler, *Project Editor*
Lindsey Westbrook, *Manuscript Editor*
Catherine Lorenz, *Designer*
Victoria Gallina, *Production*
Kelly Peyton, *Image and Rights Acquisition*

Distributed in the United States and Canada by the
University of Chicago Press

Distributed outside the United States and Canada by
Yale University Press, London

Printed in China

This book is based on "Toward a Modern Beauty:
Manet, Gauguin, Cézanne," the inaugural Getty
Museum Distinguished Lectures, presented at the
Getty Center in February and March 2016. Videos of
the three lectures are available on YouTube: "The Getty
Manet: Is Beauty Transitory?," https://www.youtube
.com/watch?v=j7rSZIlHi_4&t=1362s; "The Getty
Gauguin: Is Beauty Terrifying?," https://www.you tube
.com/watch?v=5HDvYRF02dw&t=3962s; and "The
Getty Cézanne: Is Beauty Mystery?," https://www
.youtube.com/watch?v=nVY9x2adX-w&t=864s.

Library of Congress Cataloging-in-Publication Data
Names: Brettell, Richard R., author. | Potts, Timothy F.,
 writer of foreword.
Title: On modern beauty : three paintings by Manet,
 Gauguin, and Cézanne / Richard R. Brettell.
Description: Los Angeles : The J. Paul Getty Museum,
 [2019] | "This book is based on 'Toward a Modern
 Beauty: Manet, Gauguin, Cézanne,' the inaugural Getty
 Museum Distinguished Lectures, presented at the
 Getty Center in February and March 2016." | Includes
 bibliographical references and index.
Identifiers: LCCN 2018050530 (print) | LCCN
 2018053910 (ebook) | ISBN 9781606066072 (epub) |
 ISBN 9781606066065 (pbk.)
Subjects: LCSH: Impressionism (Art) | Aesthetics,
 Modern—19th century. | Manet, Édouard,
 1832–1883—Criticism and interpretation. | Gauguin,
 Paul, 1848–1903—Criticism and interpretation. |
 Cézanne, Paul, 1839–1906—Criticism and
 interpretation.
Classification: LCC ND192.I4 (ebook) | LCC ND192.I4
 B74 2019 (print) | DDC 759.05/4—dc23
LC record available at https://lccn.loc gov/2018050530

Cover and pp. i, ii–iii, vi, and viii: Details of Édouard
Manet (French, 1832–1883), *Jeanne* (*Spring*), 1881;
Paul Gauguin (French, 1848–1903), *Arii matamoe* (*La
fin royale*), 1892; and Paul Cézanne (French, 1839–
1906), *Young Italian Woman at a Table*, ca. 1895–1900

Every effort has been made to contact the owners
and photographers of objects reproduced here whose
names do not appear in the list of illustrations on pages
98–102. Anyone having further information concerning
copyright holders is asked to contact Getty Publications
so this information can be included in future printings.

CONTENTS

FOREWORD

Timothy Potts
Director, J. Paul Getty Museum

The essays in this volume were "born audial" as a series of lectures delivered by Professor Richard Brettell at the Getty Center, Los Angeles, in February and March 2016. The lectures were inspired by the Getty Museum's acquisition two years earlier of Édouard Manet's *Jeanne* (*Spring*), 1881, a half-length portrait of an actress and model who had posed for the artist on several occasions. *Jeanne* has come to epitomize a particularly modern representation of beauty, one focused on female attractiveness and fashion. As Professor Brettell reminds us, "modern" and "beauty" are fluid concepts whose meanings change depending on the time, the place, and the interpreter. Charles Baudelaire's notion of modernity as "the ephemeral, the fugitive, the contingent" can also describe the subjectivity of beauty and the beautiful, concepts with their own complex histories.

It was Professor Brettell's intention from the start to expand his analysis beyond Manet to Paul Gauguin and Paul Cézanne, contemporaries who had decidedly different aesthetic approaches to the problem. The presence of two extraordinary paintings by them in the Getty's collection—Gauguin's still life *Arii matamoe* (*La fin royale*), painted in 1892 during the artist's first trip to Tahiti, and Cézanne's *Young Italian Woman at a Table*, rendered over several years at the end of the nineteenth century in the south of France—created the framework for a richly enlightening exploration of one of the central themes in Western art history. Readers will note that the chapter on Gauguin includes a nineteenth-century representation related to sacred Toi Moko (Maori tattooed heads). We are indebted to Dr. Arapata Hakiwai of the Museum of New Zealand Te Papa Tongarewa for his thoughtful perspective on the sensitive nature of reproductions of Maori ancestral remains. After much consideration, we have included one illustration to further scholarly understanding of Gauguin's sources and cultural context.

We are deeply grateful to Professor Brettell, among the most astute and eloquent art historians of our time, for sharing his insights on this preeminent triad of artists with a wide audience.

INTRODUCTION MODERN BEAUTY

The two terms in my title are each problematic, to use a word much in favor in current art historical scholarship. "Modern" is a word we all thought we understood until it was stretched almost to unrecognizability by the rushing of time and our attempts to define it. Few of the women and men who founded the Museum of Modern Art in New York in 1929 realized that what *they* thought was modern was already dated, colliding in various ways with the "contemporary." Yet, wisely, they did predict that what was modern in 1929 would change within a generation, and they considered gradually giving their collections to the Metropolitan Museum of Art when the artists who made these modern works had been dead for twenty-five years. "Modern," in this view, was to be constantly renewed until it became part of the pre-modern past.

I well remember a chat several years ago with a non–art historian friend who, on being told about the historical concept of "early modern," asked me, "What *is* modern, anyway?" In college, she had been taught that "modern art" began in the 1860s with Édouard Manet, modern literature a little earlier with Charles Baudelaire, and modern music with Claude Debussy. For her, like many of her fellow Americans, what was "modern" was also French. Imagine her confusion when she learned that early modern Europe, as defined by historians, was already going full tilt in 1600!

I tried my best to convince her that the "modern world" was essentially defined by globalism and mercantile capitalism, and that it had very little to do with art. This view is a matter of consensus among historians of Europe—that the "modern world" was a result of the application of these systems of exchange, with valuation rooted in trade, to the world beyond Europe. This world "modernized" at varying speeds for various reasons until, by the early twenty-first century, one could speak of the "modern world" in global terms. From a distance, Nanjing looks little different from Atlanta or Mumbai or Abu Dhabi or Johannesburg or São Paulo.

When we walk into the gallery of the earliest art at the Museum of Modern Art in New York, we see paintings by four men—Paul Cézanne,

Paul Gauguin, Vincent van Gogh, and Georges Seurat. Do we look at these paintings differently at MoMA from the way we view similar works by the same artists at the Metropolitan Museum in New York, the Musée d'Orsay in Paris, or the Neue Pinakothek in Munich? At MoMA, they sow the seeds of formal invention that lead inexorably to forms of abstraction, while at the Met they cap off the great era of easel painting that started in the fifteenth century. At the Musée d'Orsay, they react against the "academic" art on the lower floors of the museum, while in Munich they are odd French intrusions into a narrative of German art. In one setting, they are "modern," in another, "great art." At the Musée d'Orsay, they are simply "nineteenth-century," and in Munich they are "French." They are, in short, beautiful in different ways in different museums.

A solution to the quandary of "modern" will not be proposed in this volume. Rather, I want simply to stress the fluidity of the concept in various contexts, both intellectual and historical. Linguistically, the word has links to the concept of fashion (*la mode*)—links long recognized in art criticism, particularly since Baudelaire. The poet-critic's idea of modernity as transitory, even ephemeral, was at odds with notions of modernization as an evolutionary system of exchange that ends in mercantile capitalism and international trade. "By modernity," Baudelaire tells us in one of his most quoted (in translation) sentences, "I mean the ephemeral, the fugitive, the contingent, the half of art whose other half is the eternal and the immutable."

Baudelaire's sense of modernity has been fodder for historians of the arts since his essay "The Painter of Modern Life" appeared in installments in *Le Figaro* in 1863. Yet social historians of art from Arnold Hauser through Stephen Eisenman have attempted something that Baudelaire himself completely ignored: linking the modern aesthetic of the ephemeral to an economic system of fluid exchange of goods, services, and, above all else, currency. The economic concept that money gains in value as a factor of the velocity of its exchange is, in this view, related at its core to the notion of artistic modernism's fascination with speed and its attention to bursts of short duration and the progressive, if seasonal, variations of fashion.

The modern, if we can use the word as a noun, is at once a socioeconomic condition and the resulting aesthetic acceptance of the idea that change is, in itself, at once inevitable and valuable. As Baudelaire puts it, the modern is the opposite of the eternal and the immutable because

modernity is defined by change. "Transformation," "development," "improvement," "evolution," and many other words of that nature are about temporal processes, and all of this is intrinsic to the idea of the modern.

So if "modern" is always changing, what about the concept of beauty? We often hear or read the words "eternal beauty," suggesting by their very pairing that beauty is the *opposite* of modern, something enduring and unchanging. In this view, the Parthenon or the *Victory of Samothrace* or Michelangelo's *David* or Raphael's *School of Athens* are *always* beautiful, independent of the mood or character of their viewers or the time period in which this beauty is experienced. According to this notion, beauty lies in the work of art and not, as the cliché goes, in the eye of the beholder.

If we follow Johann Joachim Winckelmann and other theorists of classical beauty, we learn that perfect beauty is attained by human artists only after a lengthy process of invention, after which beauty appears briefly and, shortly thereafter, decadence follows. This process has happened twice, we are told, in Western art history: once in the Graeco-Roman world, whose apogee was Greek, particularly Athenian, art of the fifth century BCE, and then again with the "rebirth" of art in late medieval Italy, attaining perfect beauty in the late fifteenth century, before another long period of confusion and decline. The study of this latter arc of beauty was undertaken most fervently by an artist himself, Giorgio Vasari, whose *Lives of the Most Excellent Painters, Sculptors, and Architects* measured the contributions of individual artists to an art historical system. This historical condition dictates that we will have to wait another five hundred years for the next such attainment!

Theorists and aestheticians of the nineteenth century wanted to analyze these historical processes and the character of art at their apogees so that perfect beauty could, in modern times, become a continuous process in which perfection of form and content could be reproduced at will by well-trained artists in many mediums and at any given moment. Beauty became a perfection of form itself, and, should an artist combine both talent and good training, she or he could "produce" beauty in the form of a work of art.

Yet, as art critics since the eighteenth century have made clear, one person's beauty can easily be another person's ugly—or, perhaps worse, banality. But the real death knell of beauty as a powerful concept came in the eighteenth century with the codification of the concept of the sublime. To experience sublimity was, to its definers and apologists, much more

electrifying and unforgettable than to experience mere beauty, which, to them, was balanced, harmonious, and calm—in other words, *boring*. This battle for the attention of viewers reached its most dramatic point in 1827, when Eugène Delacroix exhibited his immense and chaotic *The Death of Sardanapalus* (ill. 1) and Jean-Auguste-Dominique Ingres completed his symmetrical pictorial evocation of classicism called *The Apotheosis of Homer* (ill. 2). No two pictures could be more dramatically different than these, and, clearly, only one could be called beautiful.

Living as we do in an age in which we can quantify preference by simply liking or disliking something, someone, or some event, we might, for the first time in human history, be able to determine whether patterns of "liking" persist for long enough periods to quantify beauty. Yet, in our hearts, we know that they won't. Even the most sympathetic historians of what we call taste in art tell us that the critical fortunes of artists continuously ebb and flow, if, of course, they are important enough to be noticed by collectors, critics, historians, and institutions. Sadly, the reputations of truly minor artists (the majority of all artists, really) merely ebb but never flow. I remember reading that the only artist since the fifteenth century who has enjoyed a fairly consistent superior rating is Raphael, and even Rembrandt van Rijn and Peter Paul Rubens sink from time to time. Nicolas Poussin, an artist who is consistently adored by art historians and critics, would undoubtedly fail a "like" litmus test in our youth-oriented contemporary society, and, as a person in my sixties, I well remember when artists like Al Held and Theodoros Stamos were thought to be important. Now, who remembers them except a few old people and specialists?

Perhaps because of the vagaries of beauty as a concept, art historians avoid the word "beauty" like the plague. Courses in aesthetic philosophy might be required of PhD candidates in philosophy departments, but not in art history programs. We read primary documents, critics and writers contemporary with our artist or period, and modern scholars who create historical paradigms for us to prop up or, preferably, knock down. A friend of mine—an important art historian—once told me that he was walking through an exhibition of contemporary art with another important art historian and friend, who called a particular work of art they saw together "beautiful" and then instantly felt guilty, as if he had used a taboo word. My friend found the whole thing odd, given that art historians traffic in aesthetic pleasure and its histories. But a taboo it nonetheless remains. One bright student in my own Introduction to the Visual Arts course at the

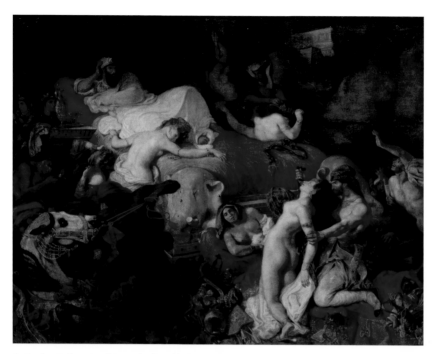

1 Eugène Delacroix, *The Death of Sardanapalus*, 1827

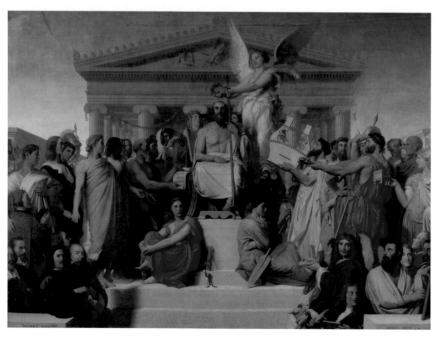

2 Jean-Auguste-Dominique Ingres, *The Apotheosis of Homer*, 1827

University of Texas at Dallas came up to me one day and asked why I never said that anything was "beautiful." "You use the words 'great' and 'important,' 'radical' and 'revolutionary,'" he said, "but never 'beautiful.'" He had put his finger directly on what might be *the* central conceptual taboo of contemporary art history.

Since art historians have made no significant contribution to the *fortuna critica* of the concept of beauty, why should I try to write a book or give lectures about it? The answer surprised even me—to define a method for thinking about beauty by doing intensive studies of three works of art by three recognizably important artists whose approach to "beauty" might be considered in a micro rather than a macro manner—in terms not of aesthetic philosophy but, rather, of the aesthetic *ambitions* of particular works of art and their makers. The evidence for this is to be found in documents, critical literature, other works of art, and repeated confrontations with the work of art within those contexts. The basic idea is that each work makes a contribution to a particular artist's notion of beauty. Neither Manet nor Gauguin nor Cézanne ever really wrote at length about beauty or "the beautiful," although Gauguin's late writing does touch on the subject in a variety of contexts. Yet they all lived in the era in which, in France at least, the beaux arts (the "beautiful arts") were contrasted with "useful" arts like furniture, ceramic vessels, glass objects, textiles, prints, and photographs. Embedded in the French concept of fine art is the word that means "beautiful," and this distinction is found in all the Romance languages, but not so obviously in other languages of European origin. In Britain and its far-flung former colonies, "fine art" is the phrase that characterizes art in museums made for no other purpose than to be beautiful. And the implication of "fine" in a museum is that the art is made to exacting standards.

Of course, all concepts whose interest persists are ultimately elusive— otherwise they would become boring sooner or later—but to combine two particularly elusive concepts into one strains credibility. Yet I throw caution to the wind here because I have ultimate faith in the aesthetic and conceptual importance of individual works of art. Indeed, in my long career I have learned that looking carefully and for a long time at individual works of art and reading the commentaries and criticisms that swirl around them are often more productive than making general comments about modernity or beauty. In this, I believe in the integrity of the work of art as I do in the integrity of the individual person in a modern, fundamentally secular society.

By the end of this process, the readers of this book and the viewers of its YouTube lecture versions (they are actually quite different) will come to a deeper understanding of two concepts—modernity and beauty—as they interrogate particular paintings with those concepts in mind. The word "interrogation" is also faddish, but I use it less because others do than because the very idea of questioning a work of art is, to me, a radical one, especially because works of art can't talk back. An interrogation begun with a mute object runs the risk of becoming a one-sided conversation, but it is not at all one-sided because the work of art is always there—always more persistent than its interrogator. If we learn to ask it questions, to inquire of it, to see whether a word or a fact or a phrase deepens in our mind as we think about it in the presence of the work, we take these ideas to a new level, and essentially contribute to a work of art's longevity.

The two Pauls (Gauguin and Cézanne) whom I discuss in this book had extravagant admiration for the older Édouard (Manet). They are each canonical in the history of modern art; in spite of various attempts over the decades to knock them off their pedestals, they remain unscathed. In two of them, "beauty" is located in the female body, but not, in these cases, in the nude. And for Gauguin, the object of his investigation is—gasp!—a preserved human head. Gauguin endeavored, through the art of easel painting, to make this gruesome object truly beautiful, and, as we shall see, he did so in ways that are fundamentally rooted in the history of Western art.

All three artists lived in the last half of the nineteenth century, a time in which museums of "great" art were easily available to them, and in the first full century of the scholarly pursuit that we call "art history." Thus, each of them worked to achieve a level of art, and to make a contribution to art, as defined by museums and their historians. As a result, all three works themselves interrogate art history as it was understood by the artists themselves. That this is "modern" might strike some readers as a contradiction in terms: How can "history" be "modern"? The answer is that, for the first time in Western culture, all people had access to history, and, for artists, this was true not only because of the accessibility of museums but also because of the wide accessibility of reproductions of works of art. Manet knew the history of European painting as well as any curator or historian of it contemporary with him, and Cézanne made a large percentage of his drawings in the Louvre, which he visited throughout his life and in which he discovered compositions, visual rhythms, and bodies (particularly bodies) that he could not experience in the actual world. And even

as Gauguin fled European urban culture to a place without museums or libraries of distinction, he took with him a large collection of photographs and prints of artworks, Western and non-Western.

Gauguin is the only one of the three, to my knowledge, who wrote about something that *all* artists have, but few discuss: visual memory, or *mémoire des yeux*, as he called it in his last completed book, *Then and After* (*Avant et après*, 1903). When one's "eyes" are constantly at work in the dance between seeing and making that is art, the power of visual memory is of real importance. Yet I know of no modern study of the visual memory of artists. This is surely because it is so difficult to gauge or measure. When we speak of "sources" of poses, figures, or compositions in particular works of art, we generally "prove" that they are correct by discovering that the artist in question actually saw the source at a particular time or owned a photograph or print of it. But when an artist spends hours and hours, day after day, making a work of art, the result is the product not only of its preparation but also of the entire earlier life and visual worlds of the artist. Staring at a model for hours, as Manet and Cézanne did, does not limit the resulting work to the visual stimulus alone. The artists' arms and wrists operated in ways coded in their bodies by years of experience, and their very choice of models, and their clothing and poses, was rooted in their *particular* knowledge of art and its histories.

The contention of these three studies is that beauty is a form of deep resonance among works of art embodied in a particular work, at a particular time, for a particular viewer. Although this statement forces us to accept the relativity of beauty in works of art, it does not locate that beauty "in the eye of the beholder." Indeed, it is a kind of struggle between the ideas of beauty embodied in the work of art by its maker and the ideas of beauty located in the experiences of the person seeing it. The result is a compromise in which neither artist nor viewer can triumph, because each has imperfectly located beauty in a work whose permanence will outlive both.

It was precisely beauty's "modernity" that Gauguin wrote about in three of his seven manuscripts: *This and That* (*Diverses choses*, 1896–98), *Idle Chatter* (*Racontars de rapin*, 1898–1902), and *Then and After*. For him, beauty was relative to one's emotional response, and it was this silent dialogue with the work of art that spoke volumes. Beauty, according to Gauguin, is an unquantifiable formula. This is why, standing before the work of a great master like Giotto, Gauguin professed to see a modern artist and not a maker of beautiful art. For this avant-garde artist, all evo-

cations of beauty across history were linked through their human connection, and their appeal could be measured through the very novelty that made them "beautiful" *for their time.*

Manet, Gauguin, and Cézanne cannot tell us what is beautiful about the three paintings under discussion here. The works have to do it on their own, and it is up to us to struggle toward a sense of the beauty in each. When I first conceived of these lectures, I felt firmly that beauty was an abstract concept of interest to aesthetic philosophers, but *not* to art historians. As I myself decided to test that concept, it hit me strongly that artists, using works of art as their medium, may make a more powerful argument for beauty and its varieties than do philosophers.

NOTE
TO
THE
READER

The three essays in this volume are based on lectures given at the J. Paul Getty Museum in 2016. Since I do not speak from notes and conceive of lectures as a kind of performance for a varied audience, I was forced to admit that the lecture transcripts created for me by the Getty did not read well as essays. Thus, I used the lectures as the basis for three new essays written wholly from scratch. Anyone who wants to understand my arguments now has the opportunity to do it in two ways: reading this book or watching the lectures on YouTube. The lectures have many more images than the book, which, for obvious economic and design reasons, cannot be so thoroughly illustrated.

The essays have benefited from editing and the views of outside readers, as well as the help of my colleague Dr. Elpida Vouitsis, who completed a dissertation on Gauguin's writings. I have taken all their reactions into account, but ultimately elected to avoid extensive scholarly discussions so as to preserve the flow and informality unique to lectures. Readers who wish to seek out my sources or read more on the three artists will find guidance in the "Suggested Further Reading" section.

Two matters arose in the editing process that ought to be addressed. The more technical of them has to do with "original" titles of artworks. This might at first seem to be a simple matter, but it is not, and I deal with it in each

essay in ways particular to that artist. Of the three primary works under discussion, only the one by Gauguin has a title inscribed by the artist on the painting (in Tahitian!), which was translated into French by him for the catalogue of its first exhibition. The Manet had two early titles, but neither can be linked through a document or letter to Manet himself. The Cézanne has had so many titles in its long life (as with Manet, none of them decisively connected to the artist) that their very number and variety constitute part of my argument. In point of fact, virtually all the titles of the works under discussion were applied to them by dealers, scholars, owners, auction houses, et cetera. Thus, I primarily use the current English titles of the works in American or British collections and provide English versions of French titles, also mentioning the French where relevant.

The second matter is more delicate, involving the cultural sensitivity that we strive for in all scholarship. All three artists were white males living in a time when the objectification of women and a colonial mindset toward the non-Western world were more normalized in cultivated society than they are today. The Manet chapter, which discusses at length the artist's relations with women, and especially his valuation of feminine youth, necessarily takes into account the social values and norms of his era. Some readers may find Manet's gaze exploitative, but it cannot be avoided in a careful, extended analysis of the work at hand.

Of all the French nineteenth-century male artists, the one who has sustained the strongest criticism from feminist and postcolonial scholars is Gauguin, whose active (even predatory) sexual life has been the subject of condemnatory writings for more than two decades. My particular lecture/essay deals not with sex, but with a still-life painting of a preserved human head, a cultural practice that has been the subject of numerous historical and anthropological studies of the indigenous peoples of Polynesia and elsewhere. No one has yet found a precise "source" for the head in Gauguin's painting, and so we have chosen to include one illustration of the preserved Polynesian heads that were widely circulated in the nineteenth century, so as to document Western knowledge of the practice in Gauguin's time. The reason I chose this particular painting for my discussion is *precisely* that it raises questions of the problematic nature of beauty in appropriated cultural contexts. In the essay, I explore the origins of this fascination both on Gauguin's part and in the long tradition of the representation of severed heads in Western art.

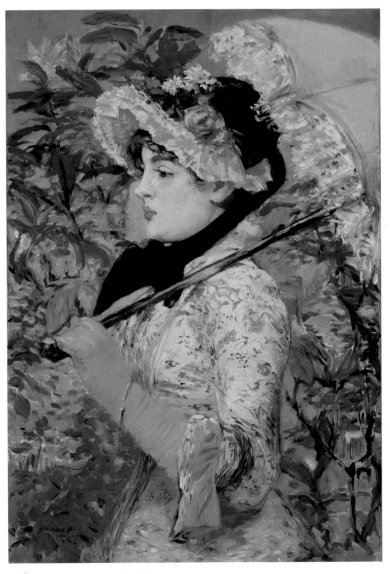

3 Édouard Manet, *Jeanne* (*Spring*), 1881

IS BEAUTY TRANSITORY?

ÉDOUARD MANET'S *JEANNE*

The Salon was the great battleground of French art throughout the eighteenth and most of the nineteenth centuries. Painters *became* important because of the positive and negative reactions to the work they submitted, which had to be formally accepted by a jury. Édouard Manet was the last great artist in the French canon who defined his own career by using, and in certain important senses subverting, the Salon. A significant rejection in 1863, when the artist was just thirty-one years old, was in all probability the single greatest coup of his career, and, rather than abandon the Salon like his younger colleagues, now called Impressionists, he stuck to it for the rest of his life—which, tragically, lasted only twenty more years.

The painting on which we focus now was one of two submitted by Manet for the Salon of 1882, the final one of his life. He died on April 30 of the following year before having completed what the brilliant Manet scholar Stéphane Guégan has identified as the work intended for the Salon of 1883, *The Escape of Henri Rochefort*, now at the Kunsthaus Zürich. It is ironic that the 1882 Salon, his last, was also the first in his life in which the works he sent were accepted without jurying; he had won his first medal the year before, enabling him to bypass the jury in 1882.

Before Guégan, critics and historians writing about Manet's last years focused their attentions on the great *A Bar at the Folies-Bergère* (*Un bar aux Folies-Bergère*, see ill. 8), which he submitted to the Salon of 1882, and, to a lesser extent, on the small floral still lifes he painted, often while bedridden, in the last two years of his life. They interpret these as a kind of farewell to painting from an artist so ill and in such pain that it was increasingly difficult for him to work. Absent in large part from the discussion is the second painting submitted by Manet to the Salon of 1882, titled *Jeanne* (ill. 3) in the Salon catalogue and recently acquired by the Getty Museum.

The Getty purchase effectively brought into the public domain a major masterpiece by Manet that had eluded the most important historians of his art because it had been in private collections, and loaned to none of the major international Manet exhibitions of the past two generations. Manet

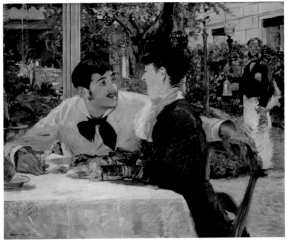

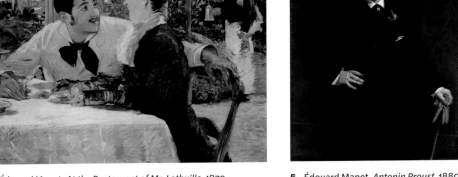

4 Édouard Manet, *At the Restaurant of Mr. Lathuille*, 1879 **5** Édouard Manet, *Antonin Proust*, 1880

submitted it to the Salon with the simple title *Jeanne*, although since that time it has often been called *Spring* (*Printemps*). Of all the late Manet figural paintings, it is the one that most overtly addresses concepts of beauty, and was admired by most critics of Manet's final Salon for its charm, its mastery of execution, and the sheer loveliness of its subject. Manet chose to call it *Jeanne* rather than *Spring,* as it was titled in his posthumous 1884 retrospective exhibition, for an obvious reason. Manet, like many artists, submitted two pictures to each Salon: a large-scale subject picture (genre, history, religion, or mythology) and a portrait. *Jeanne* was, in this sense, a follow-up to the paintings of Antonin Proust and Henri Rochefort (see ills. 5, 7) that he had shown at the Salons of 1880 and 1881, respectively. For Manet, 1882 was devoted to representations of women; the previous year he had featured two paintings of male subjects.

In fact, we should pause to consider Manet's double submissions to his three final Salons before moving to a detailed analysis of *Jeanne*. In 1880, Manet sent a painting entitled *At the Restaurant of Mr. Lathuille* (*Chez le père Lathuille,* ill. 4), the subject of which is nothing less than seduction itself. The man in this case is, as usual in French art, the aggressor, but an interesting one because his target is a well-dressed woman obviously older than he. The woman, who has been eating alone, has reached the end of her meal (she has a single peach on the plate between her demi-gloved hands). There is no place setting for the man, who firmly grasps her glass of white wine or champagne and has clearly interrupted

her. Nothing has happened—yet—but much narrative potential is conveyed, enabling the viewer to participate voyeuristically, along with the waiter in the middle ground, in this attempted public seduction.

Manet's second 1880 submission was a three-quarter portrait of the artist-administrator-politician Antonin Proust (ill. 5), whom he had known for many years. Proust is represented in "outdoor" dress, wearing a deep-blue wool overcoat and a shiny black top hat, carrying a walking stick, one glove on, one off. In contrast to the picture of seduction, Proust appears posed in the studio, as if about to be photographed in front of a banal backdrop. His almost regal posture, as many have pointed out, evokes Diego Velázquez's portraits of Philip IV of Spain, and he has the confident, unwavering gaze of a man of the world. Yet in his buttonhole is a fresh flower, a rosebud with two leaves that adds a jaunty air to what is otherwise a rather sober, dark portrait, suggesting that M. Proust is about to leave the studio and enter the streets of Paris as a flaneur, or seeker of beauty in an urban context. For Manet, the world of Proust and that of the well-dressed couple is the same—modern Paris. "The modern I have been talking about," wrote Joris-Karl Huysmans in response to the seduction picture, "this is it!" When read in this way, both of Manet's pictures in the 1880 Salon are about male-female seduction and gendered power relations in modern Paris.

The following year, themes of women and seduction—the world of Baudelairean Paris—were completely absent. Only men were allowed into Manet's pictorial world in the Salon of 1881, and his choice of men tended toward men of action: a man-about-town, M. Eugène Pertuiset, represented posing with a large, double-barreled shotgun in front of a lion-skin trophy (ill. 6), and a radical political journalist, Henri Rochefort, arms crossed defiantly across his chest (ill. 7). Manet was criticized even by friends for selecting such a polarizing figure as Rochefort for a Salon submission (he had recently escaped from Devil's Island prison!), but, oddly enough, the bizarre large-scale hunting portrait and the more conventional one of Rochefort earned Manet his first medal— albeit second class.

In 1882, for the first Salon of his career in which *any* two works he submitted would be installed without being juried, Manet ran in the opposite direction. He chose the world of women—at night and in the daylight, a working girl and a bourgeoise (at least in appearance), the former shown frontally and looking somewhat jaded, the latter in profile, beaming in youthful freshness. In *A Bar at the Folies-Bergère* (ill. 8), the world of leisure and excitement over which the woman (a waitress)

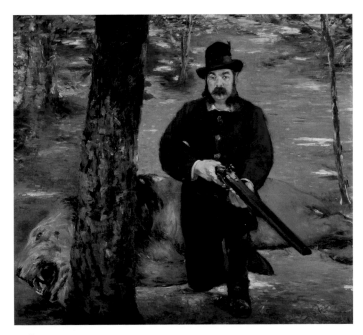

6 Édouard Manet, *Portrait of Mr. Eugène Pertuiset, Lion Hunter*, 1881

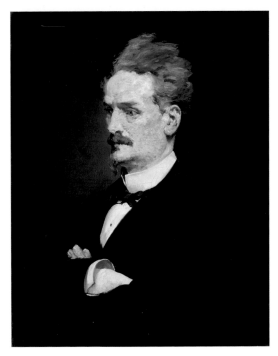

7 Édouard Manet, *Portrait of Henri Rochefort*, 1881

presides like a priestess is reflected in a mirror behind her—a reflection that has been read since the picture's first appearance as pictorially "wrong," or improbable, or both. And it is the reflection that actually dominates the large-scale surface as we scan across it, surveying all the figures, the immense chandelier, the distant balcony, the puffs of smoke, the pictorially amputated legs of an acrobat on a swing, the imperfections in the mirror. The waitress-priestess looks blankly at us from behind her altar of alcohol and oranges, a locket on a black ribbon around her neck and a gold or gilded slave bracelet on her right arm. Manet fussed over the metal foil coverings on the champagne corks, the roses in the glass, the crystals in the chandelier, the shiny orange skins of the clementines— indeed, over *everything* in the pictorial field—to such an extent that we are utterly captivated by the mirrored world of illusion. The distinguished art historian and museum professional Françoise Cachin eloquently called the picture Manet's farewell to the city where he lived his entire life and, equally, a farewell to painting.

But what of *Jeanne* (ill.9)? She must have been nearby in the Salon galleries, and, if anything, a visual foil for the angst of Manet's lonely barmaid. As in the two previous Salons, Manet thought carefully about his paired submissions, making sure they would have a joint impact and address issues not only of painting but also of modernity itself. *A Bar at the Folies-Bergère* is about consumer culture—the culture of spectacle and entertainment, with its rituals and risks. I need hardly add another word to the litany of jargon-filled essays that have already been written about it by diverse scholars, many of whom see our own era in Manet's mirror. Instead, let's look at its opposite—the portrait of Jeanne, which was more unequivocally esteemed by the critics in 1882 because it was so easy to admire. Every clever clue as to "meaning" that Manet inserted into *Bar*, he sought to deny in *Jeanne*. There is, quite simply, nothing "problematic" about it.

Then why will I examine it so carefully? The answer lies in the second term of my title, "beauty." More than any other painting in Manet's ambitious oeuvre, *Jeanne* seems to embody beauty at its freshest, its most accessible, and—this is key—its peak. Beauty, we are taught, is something elusive and, when it is experienced, undeniably powerful. Yet it is difficult for artists to make works that are "beautiful" to all viewers all the time. When we approach *Jeanne*, we see something that is as beautiful in a conventional sense as any painting of 1882. Jeanne is beautiful; her dress is beautiful; her accessories are beautiful; her pose is beautiful; her setting is

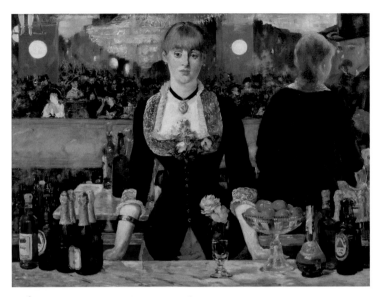

8 Édouard Manet, *A Bar at the Folies-Bergère*, 1882

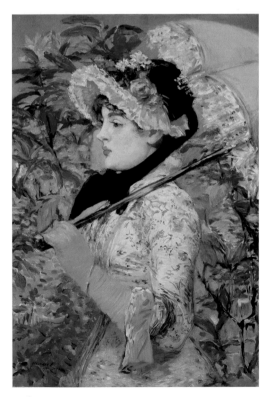

9 Édouard Manet, *Jeanne* (*Spring*), 1881

beautiful; the light is beautiful; the way she is painted is beautiful. Literally every square inch of the painting is lovingly worked by Manet's brush, even the virtuoso strokes that define the trembling foliage in the background.

Let us look first at Jeanne herself, then her clothing and accessories, then her art historical resonance, and finally her garden setting. In each of these separate investigations, we will look hard at the painting and then beyond it for some kind of context to help us clarify Manet's pictorial effects of beauty. Each of the contexts is different: one will be biographical and human; another about the role of fashion vis-à-vis the concept of beauty; next, beauty within the larger framework of the history of art; and finally the setting within the history of gardens and their plants. When we are finished with each of these interrogations, we will look together at the painting anew so as to recognize that these qualities are interlinked with the very idea of painting, of modernity—and of beauty.

Jeanne de Marsy was one of a number of women in their teens and twenties whom Manet painted in his middle age—he was forty-nine in 1881, when she posed for this particular picture. We know that his syphilis, contracted years earlier, had entered its final phases, attacking his legs, his nerves, his balance. Like most such sufferers, and many of his contemporaries were such, he worked to deny the effects of the disease and its equally debilitating treatments, which he endured in the final two years of his life. His techniques of denial included searching out beautiful young women, engaging in harmless flirtations with them, and painting them as often as he could. Their names are famous now not because of their actions in life but because of his representations of them. Isabelle Lemonnier (ill. 10), the daughter of a prominent Parisian jeweler and the younger sister of the great society lady Madame Charpentier, was one such, and in this case Manet's amusing and beautifully illustrated letters to her survive in the Musée d'Orsay. Others included Irma Brunner, Ellen Andrée, Émilie Ambre, Méry Laurent (ill. 11)—the list goes on. Indeed, many of the sitters in the numerous pastels and oil portraits of women made by Manet in the last five years of his life remain unidentified—or are deliberately misidentified, most likely because Manet wasn't making the works as portraits in the strict sense of the word. They *did* represent individual models, many of whose names we know, but they are more *filles* (young women) than particular historical women. The old trick of submitting portraits of beautiful society women to the Salon without their names attached (John Singer Sargent's *Madame X* [1883–84] is perhaps the most famous example

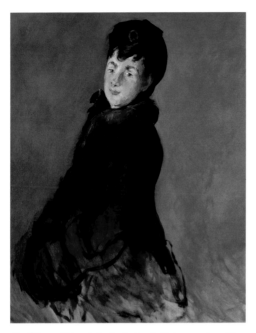

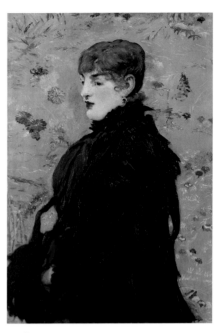

10 Édouard Manet, *Portrait of Isabelle Lemonnier with a Muff*, ca. 1879

11 Édouard Manet, *Study of Méry Laurent (Autumn)*, 1882

among thousands) was a way of denying their individuality to all but the viewers who knew them—a sleight of hand bowing to the rules of society. Women of less secure moral status—mistresses, actresses, dancers, cabaret singers, artists' models, or some combination thereof—were referred to as *fille*, *fillette*, or simply *femme* in catalogue titles, or by their first names only. Jeanne is one of those women.

Born as Anne Darlaud in 1865 in Paris (though some sources say that she was born in Limoges), Jeanne de Marsy was the younger sister of an actress, singer, and artist's model known as Jeanne Darlaud (born in 1863), who worked to introduce her beautiful younger sibling into the world of wealthy men who patronized or otherwise supported such women financially. Manet met her in 1879 or 1880 and immediately made pastel portraits of her, including her in his group of favored models, many of whom were part of what was called the demimonde, the world of pleasure and sensuality available to men of means who preferred not to enter houses of prostitution. Manet was one of these men. His interest in the demimonde had been increasing around this time in direct proportion to his inability actually to take advantage of that world, owing to his declining health and

mobility. Although he had painted women—and women of *that* world—throughout his career, he began to concentrate on this subject matter with a grim determination as his own physical powers receded. Jeanne was fourteen or fifteen years old when he first met her, and no older than sixteen when he finished this painting of her in 1881. She was not yet the actress that she became later in the decade, and, when one searches among the numerous surviving photographs of her, one realizes that they were all taken at a subsequent point in her life, when her dramatic profession was secure. In 1881, when Manet completed *Jeanne*, she was little more than a beautiful teenager over whom anxious older men were vying, hoping to help start her career.

Manet was not the only painter who recognized her charms. An almost exactly contemporary portrait of her by Pierre-Auguste Renoir (ill. 12) suggests that she made money as an artist's model. Indeed, it would be possible to mount a beautiful small exhibition of paintings and pastels by Manet and Renoir that either feature her as the primary subject or include her in more complex scenes. She has even been identified by some art historians as a small figure in the glittering society reflected in the mirror of Manet's *A Bar at the Folies-Bergère*. Thus, she possibly made her official "debut" twice in the same Salon.

It is fascinating in this context to compare Manet's *Jeanne* of 1881 with the portrait of her by Renoir painted one year later. Any dispassionate viewer would be shocked to hear that the two paintings represent the same model. In the Manet, her hair is dark, almost black, while in the Renoir it is reddish auburn. Her eyes in the Manet are brown, while in the Renoir they have a gray-blue cast. Manet portrays her in a fashionable dress, while Renoir represents her in a plain blue dress, neither the cut nor the fabric of which suggests that it was made by an important dressmaker. For Renoir, she is almost boyish in her charm, while Manet arms her with the pose and clothes of a successful woman of the demimonde.

All of this illustrates the difficulties of identifying models by their appearances in paintings. Clearly, each artist "used" the model for his own purposes, transforming her into an idea of female beauty based on his particular fantasies. These issues come to the fore again when we look at the young woman who served as the older model in Renoir's famous *On the Terrace* (originally *Two Sisters*) of 1881 (ill. 13), now in the Art Institute of Chicago. Colin Bailey, in his prodigiously documented study of Renoir's portraits, follows François Daulte in identifying the model for Renoir's

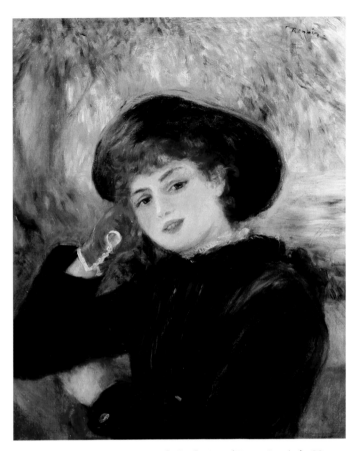

12 Pierre-Auguste Renoir, *Portrait of Miss de Marsy (Woman Leaning)*, 1882

older of the "two sisters" as Jeanne Darlaud, in real life the older sister of
Anne Darlaud / Jeanne de Marsy. Jeanne Darlaud was already an actress in
1881, and her younger sister's initiator and, perhaps, chaperone. Yet when
we compare the Chicago picture with Manet's portrait, it certainly seems
possible that the older sister in the painting could be Anne, especially since
Jeanne Darlaud and Jeanne de Marsy were both stage names. The model
for the younger sister, who has never to my knowledge been identified,
is too young to be Jeanne de Marsy, meaning that the two sisters of the
painting's original title could not have been the two real sisters Darlaud.

 Although Renoir and Manet operated in different social circles, it is
likely that the Darlaud sisters were introduced to the older artist by Renoir,
whose family probably knew the girls' grandparents in Limoges. One or the

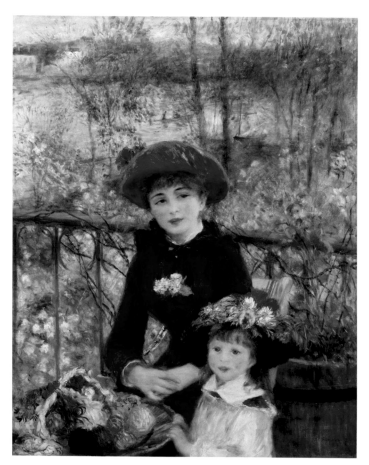

13 Pierre-Auguste Renoir, *On the Terrace* (*Two Sisters*), 1881

other of the Darlaud sisters appears with some frequency in Renoir's oeuvre, and, as I previously mentioned, it is well established that both artists painted the younger sister at almost precisely the same time. Yet, as is evident here, the identity of the sitter is not too important for our understanding of the pictures, largely because she was a paid model, not the subject of a commissioned portrait. Selected for their beauty and youth, the siblings were no more than two years apart in age, and photographs show that they resembled each other, with broad, round faces, pert, upturned noses, and widely spaced eyes. When Jeanne de Marsy appeared as *Jeanne* in Manet's 1882 Salon submission, few outside a narrow group of painters and their friends would have had any idea who she was, and that was just fine for both painter and model. It was beauty that the painter wanted, beauty associated

with young women in the largest sense, not an identifiable person, let alone one with a particular position in society. In Manet's pictorial terms, "Jeanne" could be *any* beautiful girl named Jeanne, a common name in France, especially given the revival of interest in Jeanne d'Arc (Joan of Arc).

In preparing to paint *Jeanne*, Manet had to make decisions about her dress and accessories. We know that he was fascinated by fashion and actually went shopping with and for his models. In this he was hardly alone; Gloria Groom and many other scholars have recently focused on the role of fashion and its seasonal spectacle in painting between 1860 and 1900. By the time *Jeanne* appeared in the Salon of 1882, literally thousands of fashionable women had been painted by academic and avant-garde artists in clothing that can be discussed with the same assurance and detail as one discusses actual dresses on actual women. This is because the clothing was painted from life, and the representation of it was as time-consuming and laborious as the painting of a face or a hand. Indeed, if one measures Manet's "work" on *Jeanne* by the number of strokes of paint per square inch or centimeter, one finds that every part of the picture was "worked" in a fairly equal manner. This has the notable effect of creating a pictorial surface that, though variegated, is uniformly so, almost a gestured parody of the gesture-less surfaces of much academic painting.

Manet selected a dress made from a complex floral-patterned fabric appropriate as daytime attire in the spring. It is modest almost to a fault, with a high neckline, and long, fitted sleeves with a ruffle below the elbow. Jeanne's lower arm is covered by what appears to be a suede glove, over which Manet placed a delicate gold bracelet. On her head is a black bonnet with black ribbons trimmed in off-white lace and decorated with silk flowers. A lace-trimmed parasol, the fabric of which almost matches that of the gloves, rests on her shoulder, its shiny dark shaft perhaps ebony or another expensive hardwood. Both the bonnet and the parasol would have been costly, requiring hours of labor on the part of an expert worker. It is doubtful that Jeanne herself could have afforded them, so they were likely purchased or borrowed for the painting session by Manet. The dress is uncomplicated in its cut and has few of the expensive adornments one sees in so many contemporary fashion plates: it has no piping or panels in contrasting fabric, no braided or woven trim, few ruffles, and no elaborate stitching. A simple bodice on the front is made of the same fabric as the dress; the maker seems to have wanted to show off the beautiful flower-patterned fabric and the contours of the young woman's body that it both protects and reveals.

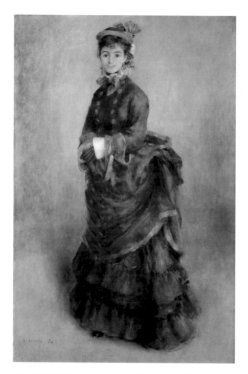

14 Pierre-Auguste Renoir, *La Parisienne*, 1874

The painting is anything but a fashion plate like those mimicked by Cézanne in the 1860s and 1870s, or those simulated in paint by Renoir (ill. 14), Claude Monet, Edgar Degas, James Tissot, Alfred Stevens, Berthe Morisot, and even Mary Cassatt. Indeed, one sees so little of the dress itself that it is difficult to comment on it, since most of the aesthetic punch of a well-made dress in France in the early 1880s had to do with the profile of the skirt and its various layers of fabric. Manet denies us the pleasure of seeing enough of the dress to imagine it in motion, and, although the woman appears at first glance to be strolling, it is apparent from the pictorial format that she is posed in a studio or, if fully plein air, in a garden. The pose is insistently a pose, not a relaxed or "natural" movement like that adopted by the same sitter when Renoir painted her. It is engrossing to think about the sheer difficulty of painting the complex fabric. The artist essentially caressed the body of Jeanne in painting the patterns of flowers as they molded to her lithe figure. It is as if his painted gestures, when broken down into pattern, allowed him to discover all her little crevices and bulges, and the very simplicity of the garment's cut made that young

body all the more visually accessible. More complex dresses that show off the designer's skill actually take our attention away from the wearer. For Manet, the dress was about the girl, not about its maker.

And before we dispense with fashion and turn to more traditional art historical subjects, it is worth exploring the genesis of the concept of "seasonal" fashion in the rise of the department store in France during the Second Empire (1852–70) and Third Republic (1870–1940). Before the public spectacle of fashion in an urban context, clothing was designed for day or night, for formal or family occasions, for warm or cool temperatures, for city or country wear. The differentiation of a "spring" versus a "summer" dress in the age of the eighteenth-century French queen Marie Antoinette would have been incidental or unimportant. Yet soon enough, seasonal fashion became a crucial marketing tool for merchants who dealt in clothing and accessories. Seasonal "collections" had come about by the mid-nineteenth century, and, for women, fashion became a temporal indicator: to be à la mode was something that trended with temperature and time. In this way, paintings representing the four seasons began to shift from the landscape and its cycles (Nicolas Poussin, Jean-François Millet, Camille Pissarro) to fashionable women who embodied temporal phases both in their ages and through their attire.

It is possible that Antonin Proust commissioned Manet to paint four seasonal paintings, each representing a beautiful woman in seasonally appropriate costume, for his private collection. *Jeanne* has always been published as the *printemps*, or spring, picture, while a portrait of Manet's former mistress and friend Méry Laurent (see ill. 11) is often identified as the autumn picture. The other two are in doubt and were, perhaps, never even begun. Stéphane Guégan, following earlier scholars, has proposed *The Amazon* (ca. 1882, ill. 15) in the Museo Nacional Thyssen-Bornemisza as the summer picture, and its three-quarter format and size make this plausible, although other Manet scholars have doubted this proposal. For winter, the only candidate is the Dallas Museum of Art portrait of Isabelle Lemonnier wearing a coat and muff (see ill. 10), but this is too large to be part of the set unless Manet, who did resize many of his pictures, intended to have this one reduced.

Manet's sister-in-law and dear friend Berthe Morisot also worked on a similarly (though not identically) sized series of seasonal pictures representing fashionable women at three-quarter scale (ill. 16). The two that survive from her series, and the two included in the Impressionist Exhibi-

tion of 1880, are the same two that are missing from Manet's series—summer and winter. One wonders whether there is a lost seasonal conversation between the two painters whose families were also intertwined. If there is truth to this, the calculus for the scholar or aesthetician would be to unify or juxtapose a man's versus a woman's representations of seasonal time in female form. And then we might ponder: If time itself—for Marcel Proust, the truest medium—is indeed gendered feminine in art, then what condition would the French consider masculine?

The seasonal was associated with female fashion throughout the Second Empire, and several artists, for instance, the Belgian Alfred Stevens and James Tissot, a French artist living in England and France, painted women in temporally appropriate costumes. For Stevens, they were embodiments of the four seasons, and for Tissot they represented the months of the year (ill. 17). The fact that Antonin Proust may have wanted a series of seasonal paintings from Manet was, therefore, almost conventional at the time, and the commission would have allowed Manet to "try out" different women from society and the demimonde with the excuse of a commission from an important collector. Stéphane Guégan, Nancy Locke, and Helen Burnham have all written about the uptick in paintings and pastels of beautiful women in Manet's art from 1879 to 1883. Guégan and Burnham also pay particular attention to Manet's use of the galleries at Charpentier's La Vie Moderne as a hybrid venue, at once noncommercial and nongovernmental, to show his oil paintings of fashionable women. Here the stakes were not so high as at the Salon, and Manet could explore his subjects' beauty outside the glare of contemporary Paris's immense art press. He could also exhibit his pastels, a medium he turned to increasingly as his health deteriorated and his periods of concentration shortened.

It is worth making a sustained comparison of Manet's spring and autumn pictures (ills. 3, 11) because both were completed shortly before his death and they clearly contributed to this late-career attempt to find beauty in women of fashion. We know that the model for the spring picture, Jeanne de Marsy, was sixteen when Manet began the painting. The model for autumn, Méry Laurent, whom Manet had met by 1876, was thirty-two in 1881, exactly twice Jeanne's age. Méry is represented in the fullness of her womanhood, not as an ingenue trying out new roles and being judged by important men. When Méry posed for Manet, she had already been his mistress and was, at the time, involved in a long-term relationship with Stéphane Mallarmé, though her actual "keepers" were men older and

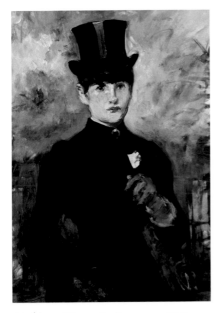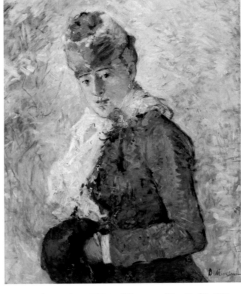

15 Édouard Manet, *The Amazon*, ca. 1882 **16** Berthe Morisot, *Winter (Woman with a Muff)*, 1880

richer than either Mallarmé or Manet. And we somehow intuit all of this as we look at Manet's representation of Méry as autumn. Wearing a black silk dress with what appears to be a feathered cape and a black ruffled collar that hides her neck, she is mature, secure enough in her position to sit stolidly and reveal her almost-double chin and prominent nose. Her hair is the natural color of autumn leaves, while the silk fabric that is her background is covered in chrysanthemums, which bloom in cold weather. If the clothes are seasonal, so too, Manet's picture argues silently, is time, and the idea that a woman's life can broadly be divided into four parts: the ingenue, innocent and naive, becoming a woman in her prime, then reaching maturity, and eventually entering old age. With this supposition in mind, it is easy to accept the proposition that *The Amazon* (see ill. 15) was to be the embodiment of summer, and equally logical to dismiss the portrait of Isabelle Lemonnier (see ill. 10) as a candidate for winter, because, despite being clad in furs and a muff, she is too young.

In the world of the four seasons, as in the world of seasonal fashion, everything is beautiful. Winter may be cold and difficult outside, but snow is beautiful and pure, shadows are blue, and life inside is warm and delightful. In each of Manet's seasonal pictures, whether part of the proposed cycle for Proust or not, beauty is present, and the painter's duty is to make

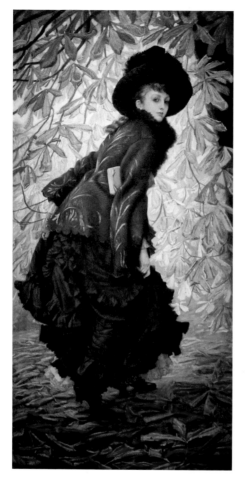

17 James Tissot, *October*, 1877

that beauty easily accessible to the viewer. The three-quarter format and pose give the pictured bodies a tactile accessibility. Furthermore, as we have observed, the details of the dress's floral pattern and the ruffles on the bonnet and parasol in *Jeanne* give the sense that the painter himself continuously touched her. I would argue that there is no more physically accessible female body in all of Manet's oeuvre than *Jeanne*. Her right eye does peek out a bit from behind her charming nose, and the bonnet sculpts her head as a whole, so the profile is not exact, but she is definitely not confronting us, and thus we are free to study her body, her face, her clothes, her gloves, and her setting without fear of the model's own intrusion. By contrast, we cannot gaze into the soul of the front-facing barmaid

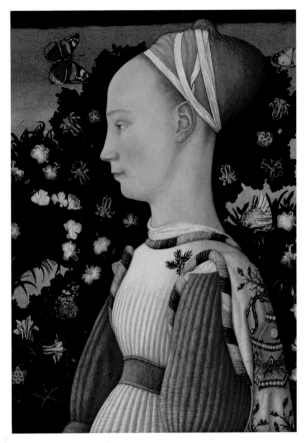

18 Pisanello, *Portrait of an Este Princess*, ca. 1432–36

at the Folies-Bergère because she is always staring back, infinitely bored with us. *Jeanne* presents no such psychological barriers. The subject looks away, seemingly unaware of us, her viewers and adorers.

Manet loved silhouettes and painted them in oil and pastel many times in the last years of his life. He knew well their long art historical resonance, particularly in relief busts, medals, and coins, and in an entire subgenre of Italian Renaissance portraiture—so many examples reside in the great museums of Europe that one can speak about them almost generically. Yet there is one in particular that I would love to imagine having been foremost in Manet's mind: Pisanello's *Portrait of an Este Princess* (ca. 1432–36, ill. 18) in the Louvre. Pisanello shows us an unnamed princess, her head in strict profile but her body turned slightly toward us so that we can understand its volume and the fabulous luxury of her dress.

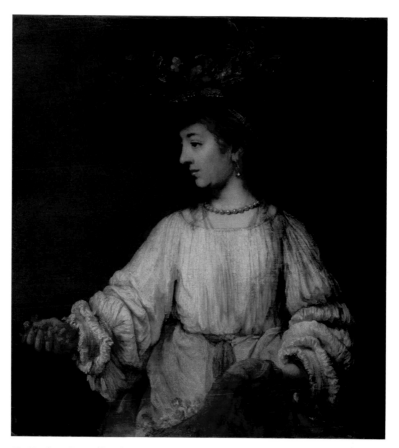

19 Rembrandt van Rijn, *Flora*, ca. 1654–60

We don't need to know a thing about her to identify her as young, possibly unmarried, and represented in portrait form to snare a distant suitor—or, just as likely, a young bride or recently married woman who looks into the eyes of her fiancé or new husband in another, now missing, pendant painting. Like *Jeanne*, she is pictured in front of a flowering shrub, but here there are butterflies, who can alight on flowers and pollinate, reinforcing the idea that this was an engagement or marriage portrait.

If only Manet *had* known this picture, the argument for it as a primary source would be undeniable. Yet he couldn't have, because it did not enter the Louvre's collections until 1893, a decade after his death. Despair not, however, because if the link here is not a real one, Manet, like any literate artist, would have known, either in reproduction or in the original, other such portraits from the fifteenth century, when they were made with some

frequency. He didn't need a particular Este princess painted by Pisanello to spur his imagination in the direction of what we today call "museum art." He was already versed enough in museum collections, having visited Spain and Italy and having a good collection of photographs and art books of his own, including Charles Blanc's multivolume history-of-art survey. It was the *idea* that the young woman in profile had a distinguished provenance in Western art history that spurred Manet to make his portrait of Jeanne in profile. He also likely knew of the phenomenon of paired paintings of wives and husbands, meaning that, for him, Jeanne was looking into the eyes of a man depicted in another painting rather than at the viewer. The exclusivity of this gaze is a privilege that no one but the painted figures themselves experience, and Manet's fantasy life was not unsusceptible to such connections.

The art historical world is full of paintings of beautiful women made by men toward the end of their careers, and many of these are associated with "flora" or "flower" and can be thought of as muses. Rembrandt van Rijn painted three *Floras*, each representing his wife, Saskia, at a different moment in his career. The one with the most resonance with Manet's *Jeanne* is the *Flora* in the Metropolitan Museum of Art, which was painted after the subject's death (ill. 19). The very idea of a posthumous (dated variously from about 1654 to 1660) evocation of a beautiful woman by Rembrandt, painted using an earlier portrait of his deceased wife as a model, suggests that one artist's *memory* and *representation* of beauty evolved into another's embodiment of time, and of nature's cyclical shifts, as intrinsically feminine.

I use the word "resonance" advisedly, because Manet could never have seen Rembrandt's picture, which resided during his lifetime in the private collection of the earls of Spencer in England. And yet I cannot help connecting the *ways* in which the works in question are beautiful. Rembrandt invoked the beauty of his late wife by reimagining her as alive. In this case, he himself had no sense of his own mortality; it was *her* death that preyed on his imagination, urging him to use his art to revive her beauty and presence. It was the opposite for Manet, whose looming mortality made him want to evoke the palpable youth of a sixteen-year-old model and to render it with such care that it would be frozen in time, immortalized in art.

Each of the paintings perfectly serves its aesthetic aim: to invoke an absent beauty (Rembrandt) and to arrest the bloom of youth (Manet). Saskia's pose combines frontal (the body) and profile (the head), linking

corporeal life with psychological distance. She wears a large hat on which Rembrandt painted fresh leaves and flowers. Her right hand reaches out to pluck another flower, to join those gathered already in the ample folds of her yellow skirt, held up by her left hand. Manet's *Jeanne* is at once radically alive in her sheer physical presence and psychologically inaccessible, her gaze impenetrable as her perfect head looks away from us. If there is a poignant nostalgia in Rembrandt, Manet allows us no such emotion. Jeanne is forever apart, confident in her own clothes, unaware of being painted or viewed. Remember that in the Salon she was simply *Jeanne*, but when she reappeared in the posthumous 1884 retrospective exhibition curated by her first owner, Antonin Proust, she was given the added burden of the word *Spring*. She is *both* Jeanne and an embodiment of the season associated with beginnings and awakenings. I suspect that she was *Spring* for Proust and *Jeanne* for Manet.

Jeanne is shown out of doors in a garden. The painting allows us little understanding of it other than a flowering rhododendron tree, whose branches, leaves, occasional white blooms, and red buds Manet evokes with lively, overlapping strokes. Rhododendrons became fashionable in English and French gardens only in the middle of the nineteenth century, when they enjoyed almost a craze. I remember touring the famous gardens at Stourhead with a British friend who ranted about the "horrible Victorian fashion of rhododendrons" that, to him, destroyed so many eighteenth-century gardens like that one. He considered their leaves ugly and their multicolored flowers vulgar. They bloom in profusion in April, displaying deep red, orange, yellow, purple, pink, magenta, and—yes—white blossoms, as in Manet's picture. Native to high altitudes in Nepal, India, and the Appalachian Mountains in the United States, these bush-like trees can grow to great heights. In the Manet, we see a crossed tangle of branches at the upper left and lower right, and a few hints of the multi-floral effulgence of blooms in the upper left and elsewhere. Knowing that white rhododendrons have reddish coverings on the buds explains the stray touches of red and reddish brown in the almost formless brushstrokes. All in all, the effect of the planted background is to let us know that Jeanne is not in nature but in a planted garden—as artificial in its own way as the silk flowers on her hat and the printed flowers on her dress. The brushstrokes also serve as markers of Manet's own craft: he worked on the surface of *Jeanne* every bit as hard as he did on the frenetic painted reflection in the mirror behind the barmaid at the Folies-Bergère.

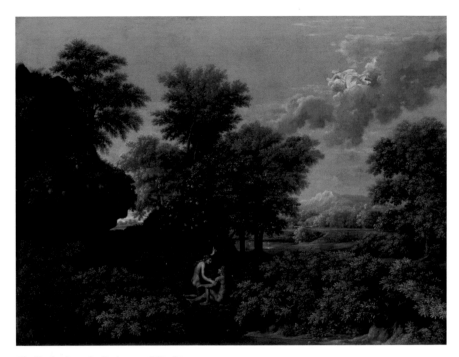

20 Nicolas Poussin, *Spring*, ca. 1660–64

Of all the seasons, spring is perhaps the most easily "beautiful" both physically and symbolically. Yet Manet knew his art history, and was familiar with the most famous "spring" in the Louvre—the one from Poussin's *Four Seasons* (ca. 1660–64, ill. 20). Poussin is not among the artists one readily associates with the supremely painterly Manet—that honor goes most fervently to Velázquez. However, all French artists knew the biblical nature of Poussin's *Four Seasons*, painted as the last major commission of his life. Poussin's spring is set in the Garden of Eden—an unlikely place, considering that apples mature in the autumn, but probably chosen by the artist because the fall of humanity from a heavenly garden to an earthly one embodied a new beginning. When we look again at *Jeanne* with the sense of Manet's own illness, the beautiful young woman takes on a moral weight as a representation not merely of youth but also of temptation. And, in this weighted reading, the painting plays its dichotomous role with the jaded barmaid at the Folies-Bergère, whose knowledge of the world of temptation was surely greater than Jeanne's. For Manet, the transience of innocence, like the transience of youth, could be arrested in art to become permanent—or as permanent as an oil painting on canvas can be.

21 Édouard Manet, *Nina de Callias*, 1873

A fascinating postscript to this pictorial ode to beauty is that it may be the first work of contemporary art to serve as the subject of a color photograph. In the twenty-first century, digital color representations of paintings are so ubiquitous that we might be forgiven for thinking that *all* paintings have always been reproduced in color. Yet such is not the case. In 1881, when *Jeanne* was finished and signed, not a single successful color photographic reproduction of a painting yet existed, and color photography itself was not to become widespread until the next century. We know, however, that Manet was friendly with a scientist-poet named Charles Cros, who (at almost the same time as a then-obscure photographer named Louis Ducos du Hauron) had announced the invention of color photography in 1869. Both photographed their subjects with filters that recorded each of the three primary colors, then printed the negatives successively using translucent lithographic ink to form a color photographic print. (It is clear from even this simplified explanation that their methods were flawed; the "photographs" looked like conventional tri-color prints common in French graphic art, but with a photographic matrix, rather than like color photographs as we understand them today.)

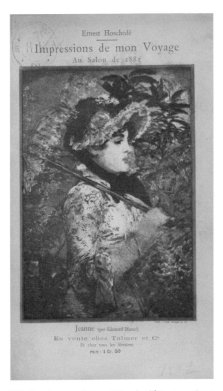

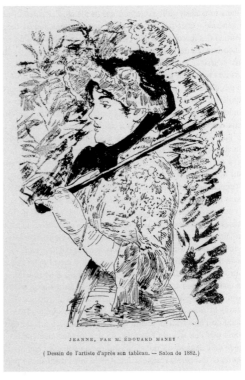

22 Front cover of Ernest Hoschedé, *Impressions of My Trip to the Salon of 1882* (Paris: Typographie Tolmer et Cie., 1882)

23 Black-and-white reproduction of Manet's drawing of *Jeanne*, after his painting, in Antonin Proust, "Le Salon de 1882," *Gazette des Beaux-Arts*, June 1, 1882, 545

No early color photographs by Cros or Ducos du Hauron survive, but their processes were similar, and Cros was still fully engaged in his experiments when his friendship with Manet began in 1873. Manet painted Cros's mistress, the infamous Nina de Callias (ill. 21), and was a regular at the couple's evenings at home. After he completed *Jeanne*, he began a collaboration with Cros to produce a color reproduction of the painting. He himself made a drawing and a wiry, linear etching based on it, possibly in conjunction with Cros.

Cros's color photograph of *Jeanne*, printed in reverse, appeared on the cover of Ernest Hoschedé's *Impressions of My Trip to the Salon of 1882* (*Impressions de mon voyage au Salon de 1882*, ill. 22), published the same year as Manet's last Salon submission. And Manet's drawing after his painting *Jeanne* was published in Antonin Proust's review of the 1882

Salon in the June 1, 1882, issue of the *Gazette des Beaux-Arts* (ill. 23). Both "reproductions" fall curiously flat, in such a way as to remind us all of Walter Benjamin's worry that a surfeit of reproductions will sap a work of art of its "aura." Well, Benjamin would have had no fears in 1882, when Manet and Cros made their efforts public. Indeed, the aura of the original *Jeanne* is as bright as ever, because, no matter the quality and resolution, no reproduction will ever be painted by Manet so as to convey his own thoughts and feelings directly.

Jeanne represents a beauty that *was* fleeting, and this surely nagged at Manet given the short duration of his own life. She is still with us at the Getty, more alive than ever. If Manet had lived, he surely would have thought her more beautiful in his painting than in all the glamorous photographs taken during her subsequent career as an actress. In *Jeanne* she is not acting, but, rather, an embodiment of what we might call eternal youth. The freshness of her complexion and the wonderful firmness of her body beneath that flower-print silk would inevitably fade in real life, but Manet arrested them in art. Using art, Manet allowed his particular notion of beauty to speak beyond *his* present and be experienced fully in ours.

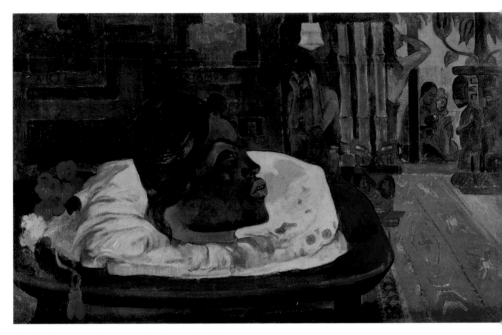

24 Paul Gauguin, *Arii matamoe* (*La fin royale*), 1892

IS BEAUTY IMMEMORIAL?

PAUL GAUGUIN'S *ARII MATAMOE*

The severed head of a young, dark-skinned, indigenous man, bloodless and cool, rests on a white pillow placed on a four-legged carved wooden table or platter on a pink carpet in a darkened palace interior. Behind the head is a naked androgynous figure, eyes wide open, crouched against the wall, and another young woman wearing a blue *pareo* (traditional Tahitian wraparound skirt) seems to call out into a landscape with a brilliant yellow sky. Two other women, one wearing a red hooded garment, as if a priestess, seem to converse in the middle ground. The room contains a pair of carved idols on the right and a brightly painted head with immense blue eyes sporting what looks like red antennae in the center. Three large bamboo columns divide the room above this head, and, on the darkened walls to the left, we see two other evocations of a face with two large blue eyes and two mysterious words, separated enough that we consider them one by one: *ARII MATAMOE*.

This is what we see in the picture (ill. 24) that Paul Gauguin described in a letter to his friend Georges-Daniel de Monfreid in June 1892: "I just finished a Kanak head, nicely arranged on a white cushion in a palace of my own invention and guarded by women, also of my invention." His characterization is the first ever written about one of the strangest and most original still lifes ever painted. Indeed, it is an odd candidate for a discourse on beauty, unless, as I do, one wants to see how far that concept can be stretched in modern art. Here, Gauguin has transformed something that ought to be ghoulish, even terrifying, into a work of art. The young man whose head we examine has a beautifully structured face, wonderful hair, sensuous lips, and eyes looking upward as if in a swoon. He is, in this way, utterly beautiful, and easily an object of intense fascination for any viewer. Who was he? Why and how did he die? Was he beheaded before or after death? This principal object in the still life will tolerate us looking at him for as long as we like, undisturbed by our gaze.

The white cushion is beautifully conceived by Gauguin to take our mind off the manner of the beheading. It seems the perfect soft place, relieving

us from seeing the end of the neck. No blood, no blade cuts, no violence of any kind interrupts the serenity of the head. When Gauguin first showed the work at Durand-Ruel Gallery in 1893, the year after it was painted, he titled it *The Royal End* (*La fin royale*), the artist providing his own translation from Tahitian in the exhibition catalogue, and from this we suppose that the head belonged to a king or, at the very least, a prince. But it is his apparent youth that touches us. If he was a king, he died while in the prime of his life, not as an old, venerable ruler. But is "the royal end" really what Gauguin meant by "la fin royale"? Could he have meant something else, something more profound—the end of royalty itself, perhaps? Could this young man be the last ruler of a kingdom that has vanished forever?

The title of the painting was "translated" by Gauguin from the two Tahitian words he inscribed on it: *arii* and *matamoe*. His knowledge of Tahitian has often been challenged, and pedantic scholars from Bengt Danielsson onward delight in revealing his mistakes and misunderstandings. So, what do those two words mean? *Arii*, which can mean "king," "prince," or "chief" in Tahitian, suggests nobility, and Gauguin first translated the term as "king" in his book *Ancient Maori Beliefs* (*Ancien culte mahorie*), written about the same time as he made the painting. The conjoined word *matamoe* is derived from the Tahitian word for "eyes" (*mata*), and the suffix *moe*, which generally indicates sleep or slumber. Thus, *matamoe* literally translates as "sleeping eyes," and, as a compound adjective, it means "asleep." For Gauguin, this term symbolized death or "the end," but was not strictly limited to that association. The Tahitian dialect allows it a broad range of meanings, including "strange" or "unknown." Furthermore, on its own, *moe* means not only "sleep" but also "lost," invoking mystery and foreignness. These various definitions and meanings, according to Danielsson, would have been accessible to Gauguin from Tepano Jaussen's Tahitian-to-French dictionary published in 1887, *Dictionary of Maori Grammar and Language: [In Its] Tahitian Dialect* (*Grammaire et dictionnaire de la langue maorie: Dialecte tahitien*), with a later edition appearing in 1898.

Despite the numerous ideas and symbolic meanings evoked by the term *matamoe*, Danielsson commented in 1967 (as part of a larger exploration of the Tahitian titles of Gauguin's paintings) that the best solution in defining the Tahitian terms employed by the artist was to consider his French translations as the correct ones. This emphasizes the death symbolism, but there is a quality of life in the head that allows us to imagine that, despite its severed-ness, it is somehow only sleeping. Its peaceful and

silent quality, resting on its throne of soft whiteness, cannot be denied, and the sheer beauty of Gauguin's representation undercuts what would otherwise be an instinct toward fear or loathing.

Garlanding the head is a cluster of red hibiscus flowers, an unidentifiable yellow flower, and a mysterious red tassel on twinned golden ropes. This detail leads us to identify the cushion as the bag in which the head was transported to the room. The flowers are shown with their leaves, indicating that they have only recently been placed next to the white cushion. This cushion is subtly embroidered with small green circles with five red lines dividing them and a floating green triangle in between the orbs. The origins of these forms are not definitely known, but their position on the cushion connects them to the abstract forms in the patterned edge of the pink carpet on which the head rests.

This carpet is the only part of the painting that suggests a culture that is non-Polynesian. Its border has forms derived from Middle Eastern carpets, and, given that there was no cloth weaving in Polynesia at the time, no carpet like the one suggested by Gauguin could have been made locally. Remember his insistence that the palace was "of my own invention," and, since Gauguin had been in Tahiti only about a year when he painted this picture, his access to indigenous objects was not as great as it was later in his stay. All the rest of the palace decor is derived from verifiable Polynesian sources. But since no indigenous interior of this complexity then existed on the island, Gauguin *had no choice* but to invent it (as per his own letter) from accessible sources.

Looking carefully, we realize that the head is not on a plate, but on a carved wooden table or platter with four legs, like the tables/platters Gauguin had come to know in Tahiti and was to use in later illustrations in his major book about the island, *Noanoa* (1893–94). In a drawing preserved at the Art Institute of Chicago, a sheet with two studies of a Polynesian female model, Gauguin also made a careful drawing of an ear spool (ill. 25), which he must have seen either in a book or in a local collection (ill. 26). He borrowed its tiny carved form, enlarged it, and used it as the wall decoration behind the head in *Arii matamoe*, on which he wrote the Tahitian title of the painting. One can also find sources in Tahitian indigenous art for the strangely painted idol and the double-figured stool to the right of the head (ill. 27). We cannot know for sure the precise "source" for each element of the painting because none of the artist's preparatory drawings for it survive. But we can say for certain that Gauguin's pictorial feat of invention regard-

25 Paul Gauguin, *Two Tahitian Women and a Marquesan Earplug*, ca. 1891–93

26 Polynesian, *pu'taiana* (ear ornaments), nineteenth century

27 Patoromu Tamatea, *Round Bowl with Lid with Two Figure Supports, Kumete,* ca. 1850–1900

ing this palace interior was considerable. He borrowed decorative elements from sources that were significantly smaller than the represented interior and imaginatively enlarged them to suit the depicted space.

Gauguin invented idols, musical instruments, costumes, dance moves, temple sites, and the like, knowing that all of this had been lost to the Tahitians themselves through colonialism and the zeal of the competing Protestant and Catholic missionaries. This act of aesthetic recovery is a crucial attribute of the picture, and of this phase of Gauguin's Tahitian career. He represented not the Tahiti he saw but the Tahiti that he *imagined* having been lost—the Tahiti he sought, not the Tahiti he found—and this is the triumph of imagination over experience, a kind of aesthetic cultural anthropology for which his sources were books, objects, and conversations, however halting, with indigenous people. His respect for them and his sense of participation in their loss was the bedrock of his Tahitian art from the early months of 1892 until he departed for France about a year later (he would return in 1895 and remain there until 1901, two years before his death).

If Gauguin conjured a Tahitian royal palace from ear spools and other small carved objects, he was at a greater loss for the figures, for whom

MOMIE TRÉPANÉE,
de Piedra Grande del Ucahumba.
CHACHAPOYAS, PÉROU.

28 Photographs of a Peruvian mummy, twelfth–fifteenth century, exhibited at the
Musée de l'ethnographie du Trocadéro, Paris, 1878 Exposition Universelle

he had only generic models. For the small female middle-ground figures,
he turned to his own trusty repertoire: his earlier paintings. The crouch-
ing figure directly behind the head, for instance, originated in a Peruvian
mummy bundle that he had seen and made multiple prior uses of to signify
death. In all these cases, the figure is female, although the mummy bundle
was simply skeletal remains arranged in the fetal position (ill. 28). Clearly,
Gauguin was fascinated with the birth-death binary of the pose, and when
he constructed this mourning figure he had repeated it so often before
that he had no need to look at his earlier works (which were, in any case, in
France rather than with him in Tahiti).

To the right of this mourning figure is another woman who appears
with even greater frequency in Gauguin's pre-Tahitian work. Her origin is a
female nude plunging into the green waves of the sea in a painting entitled
both *Ondine* and *In the Waves* (1889, ill. 29), now in the Cleveland Muse-
um of Art. The original figure's sense of abandon, vitality, and danger is
reduced considerably here, since Gauguin has dressed her in a blue *pareo*,
but the bent arm is powerfully directed outward, suggesting that she is
either crying out or gesturing toward the landscape in despair and grief.

The two remaining figures are the most interesting of the group in
that, rather than relating to figures from Gauguin's pre-Tahitian oeuvre,
they point *forward* to a pair of figures that would haunt his career until
1903, the year of his death (ill. 30). Of the two, one is a Polynesian woman

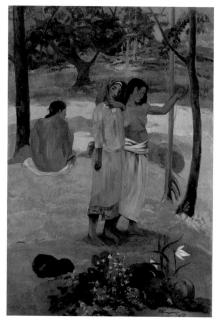

29 Paul Gauguin, *Ondine (In the Waves)*, 1889

30 Paul Gauguin, *The Call*, 1902

wearing a *pareo*, seated on what appears to be a porch outside the palace interior and holding an implement that has never been conclusively identified or interpreted. My colleague Elpida Vouitsis, who has just recently completed brilliant translations of Gauguin's seven texts, has remarked that it resembles the general shape of an ax as echoed in Gauguin's narrative in chapter 4 of *Noanoa*, when he describes chopping down a tree for some wood to make a sculpture, instigating a symbolic destruction of his Western self and discovery of his primitive roots, while appeasing some sort of divine savagery. If Gauguin had this in mind when he painted the object, his earlier idea of death and rebirth from his 1889 painting *Life and Death (La vie et la mort)* at the Mohamed Mahmoud Khalil Museum in Cairo is again evoked here.

Next to her is another seated figure, this one with no links to Polynesia in her costume, which is a hooded red garment entirely covering her except for her face and one leg. This woman has no direct precedent in Gauguin's oeuvre but appears again as a standing figure in a similar red garment in the important 1897–98 painting *Where Do We Come From? What Are We? Where Are We Going? (D'où venons nous? Que sommes nous? Où allons nous?*, ill. 31) at the Museum of Fine Arts, Boston. Both figures suggest a kind of

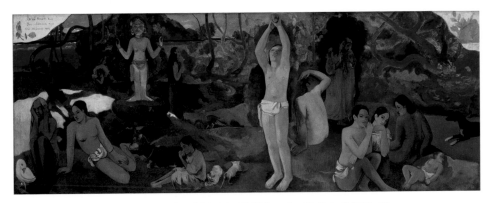

31 Paul Gauguin, *Where Do We Come From? What Are We? Where Are We Going?*, 1897–98

immemorial priestess with no specific cultural origins but whose costume casts her as distinctive and important (ill. 32). She and her companion both crouch and face away from the royal head, in conversation or collusion. The four women are variously "gendered" visually, and, were it not for Gauguin's letter to Monfreid, we might conclude that their gender was unimportant to Gauguin, or that he accepted what many Europeans found to be the androgynous quality of Polynesian women. Indeed, even the royal head has a kind of beauty associated more with women than with men.

This catalog of the elements in the picture demonstrates that Gauguin delved into the recesses of his visual memory; that he adapted forms from other contexts; and that he wanted to convey a vague sense of luxurious authenticity in creating the environment for the head. But what of the head itself? In his 1892 book devoted to the belief systems and cultural practices of the people then called the Maori, *Ancient Maori Beliefs*, he copied many long passages from a two-volume survey by the Dutch scholar Jacques-Antoine Moerenhout, *Travels to the Islands of the Pacific Ocean* (*Voyages aux* îles *du grand océan*), published in 1837. One of the lengthy passages is given a section of its own entitled "The Election of a King." In this detailed excerpt, there is not a single reference to beheading or to the head of a past king. Following Moerenhout's description, Gauguin repeatedly refers to a corpse in its entirety and relates rather gruesome acts of veneration, including a powerful account in which a priest rips out the eyes of a sacrificed person, placing the right eye next to the god's image and offering the left eye to a newly elected king to consume; the priest then pulls the left eye back before the king can eat it, and returns it and the other eye to the corpse.

32 Detail of ill. 31

Another nineteenth-century writer who described a ritual like this was Pierre Loti (born Julien Viaud in 1850) in his popular 1878 novel *Loti's Wedding* (*Le mariage de Loti*), about a French sailor who discovers love in Tahiti and then abandons the woman, and she laments his departure all the way to her grave. In his description of a simulated sacrifice, Loti writes that a corpse's eyes were removed from their sockets and *both* presented to the *queen* on a *platter*. In *Arii matamoe*, the effeminate appearance of the king and the table-platter are evident, suggesting that Gauguin was combining different Western accounts of an extinct or, possibly, invented ritual. We also know that Gauguin read Loti's novel and wrote about the author in his own books, even modeling his fictional love story, *Noanoa*, on Loti's narrative.

So, how exactly are we to read this painting and all of its "sources"? None of these accounts are perfectly embodied by the beheaded king in

Arii matamoe, whose eyes are in place and who projects an air of silent tranquility even in death. This image is far from the violence and sexualized ritual that Gauguin borrowed from the Dutch scholar, and likewise from the pair of eyes ripped from a sacrificed corpse and offered to a queen for her consumption according to the French novelist. It seems relatively safe to conclude that rather than relying solely on ethnographic descriptions by earlier Europeans, Gauguin elected again to delve into his own prodigious visual memory and remember the shrunken and/or preserved heads from New Zealand that he may have seen in ethnographic displays at the Exposition Universelle of 1889 in Paris.

Two such heads, which Gauguin may well have seen, had been introduced at the Société d'Anthropologie de Paris on October 23, 1879, by the physician Paul Broca, who presented them as trophies from an insurrection led by a local chief on September 1, 1878, in New Caldeonia, which includes the Loyalty Islands, a cluster off the east coast of Australia. In 1774, the explorer James Cook was the first European to arrive in New Caledonia, which eventually became part of the French Republic under Napoléon III in 1854. The rebellion led by the native chief in 1878 was an expression of resistance against colonial oppression. The two heads presented to the anthropological community in France in 1879 were identified as those of a New Caledonian grand chief named Ataï and a "sorcerer."

Preserved heads became trophies of sorts for European ethnographers, physicians, and anthropologists (ill. 33), many of which today are being restituted to their places of origin by countries such as France. For the Maori, the idea of preserved heads seems to have been associated with the continuance of ritual power, and the heads were carefully preserved and tattooed by indigenous peoples as an assertion of dynastic authority after death. Western explorers going all the way back to Cook in the mid-eighteenth century and Jules Dumont d'Urville in the early nineteenth, however, considered the heads of chiefs and warriors tradable commodities and collectibles, the impact of which, according to almost all recent scholars, has greatly perverted the world's understanding of the indigenous traditions in question.

When we look at modern photographs of these heads, it is apparent that it was the *idea* of the heads, not the specific qualities of any particular one, that Gauguin sought to evoke in *Arii matamoe*. The large majority of the surviving heads in museums are tattooed and all of them have their eyes removed, which is decidedly not the case with Gauguin's head, with

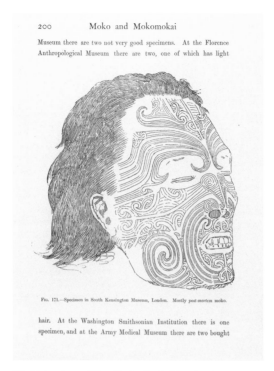

Museum there are two not very good specimens. At the Florence
Anthropological Museum there are two, one of which has light

FIG. 171.—Specimen in South Kensington Museum, London. Mostly *post-mortem* moko.

hair. At the Washington Smithsonian Institution there is one
specimen, and at the Army Medical Museum there are two bought

33 Major-General Horatio Gordon Robley, drawing
of a female Maori head, 1896

its upturned gaze. We intuit that Gauguin wanted to make his head beauti-
ful not only because of its features but also because he omitted any sign
of decapitation or surface marks associated with preservation. Indeed, I
would argue that we are being asked to gaze upon this beautiful young pre-
served head in ways little different from how we gaze at Manet's eternally
youthful *Jeanne*.

Gauguin himself had a long and fascinating relationship with
heads, starting no doubt with his childhood memories of the pre-Hispanic
Peruvian ceramics that he saw in Lima and, later, at his uncle's house in
Orléans, France, and in his mother's collection. He had visual knowledge of
the famous Moche heads (ill. 34), which represent either important men
or beheaded captives, perhaps even beheaded kings who were captured
in battle. Before he distantly evoked these heads in *Arii matamoe*, he
used them as a model for an important 1889 self-portrait, which was the
first Gauguin ceramic to enter a public collection and is among the most
remarkable works of his entire oeuvre (ill. 35). This head, like that of the

34 Peruvian, Moche portrait vessel of a ruler, ca. 100 BCE–500 CE

35 Paul Gauguin, *Self-Portrait as Severed Head*, 1889

young king in *Arii matamoe*, appears to lean back and stands on a stump-like neck that bears no obvious physical traces of beheading. We know that Gauguin personally witnessed the botched beheading of a young alleged murderer not more than two weeks before he created the 1889 self-portrait, because he later wrote about it, first in his 1893 illustrated manuscript *For Aline* (*Cahier pour Aline*), started about six months after he completed *Arii matamoe.* Gauguin was fascinated by the event, which took place at the Place de la Roquette on December 28, 1888, and described it in even greater detail in his book *Catholicism and Modern Consciousness* (*L'esprit moderne et le catholicisme*, 1902), and again in his last, *Then and After* (*Avant et après*), completed in February 1903.

This trail of memories and events stretching back into the artist's childhood and forward to the end of his career is both remarkable and, more interestingly, typical of Gauguin, who manifested throughout his life an ease with conjoining memory and experience. He was never able to see with the reductive visual concentration of the Impressionists, who

attempted to transcribe the effects of light on form at a particular time. His earliest Impressionist works are replete with distorted, borrowed, and layered memories, images, and experiences. For Gauguin, it was always associations and suggestions of forms that appealed, never merely their appearance. There was no *now* for him as there was for Alfred Sisley, Pierre-Auguste Renoir, and Claude Monet.

Gauguin's acceptance of this complexity of time, experience, and memory is readily demonstrated by comparing *Arii matamoe* with a select group of earlier still-life paintings with similarly layered temporal and aesthetic structures. We could begin almost at the start of his life as a painter with the inventive *The Two Pots* or *Wood Tankard and Metal Pitcher* (1880, ill. 36), now in the Art Institute of Chicago. There are many still lifes with containers in the history of northern European art, but none I can find that represent them simply placed on a table. Usually in still-life painting, the artist spends a good deal of time arranging the elements in a complex composition of volumes and voids, rectangles and circles, darks and lights, transparencies and opacities. Not so for Gauguin: this is a juxtaposition, adamantly *not* a composition. In doing this, Gauguin forces us to contrast and compare the two vessels.

The frustrating aspect of this painting for those who like neat interpretations is that it seems to relate directly to a fable by Aesop and, in rewritten form, La Fontaine (and we know Gauguin had a fondness for fables). This one is entitled "The Iron Pot and the Clay Pot" and has, like all fables, a moral lesson. The brief version is as follows: The iron pot says to the clay pot, "Let's go on a trip," to which the clay pot replies, "But I might break." The iron pot assures the clay pot that he will protect her (note the genders), and the clay pot reluctantly agrees. The trip begins and the clay pot falls off the donkey to which they are both attached, and breaks. The moral of the tale is to know your own nature. This is a wonderful literary key to the painting, at least at first glance, but nothing with Gauguin is simple.

Looking closely at the two pots in the painting (and of course attending to the alternate title), we see that one is made of metal (in this case, tin) and that the other is a wooden *tine*, of Danish origins (like Gauguin's wife, Mette). So, this painting might instead be called *The Tin Pitcher and the Wooden Beer Container*, not *The Iron Pot and the Clay Pot*. The wooden *tine* might well crack, but it will surely never break. What are we then to do as interpreters of this enigmatic painting? The answer, of course, is to accept as aspects of its meaning *both* the fable and the actual containers

36 Paul Gauguin, *The Two Pots* (*Wood Tankard and Metal Pitcher*), 1880

chosen by Gauguin, which leads us to interpret this seemingly simple still life as a symbolic portrait of a marriage. Marriage was a topic that Gauguin discussed in his books as well, paying particular attention to the degeneration of this hallowed institution in modern times.

Moving on, let's look at a somewhat later still life in a private collection in Switzerland, with the simple title *Still Life in an Interior* (ill. 37), painted in Copenhagen in the winter of 1885. I choose this one because as a composition it is so similar to *Arii matamoe*, yet it is mysterious in different ways. Gauguin arranged a basket, the same *tine* we just saw, onions, cloth, and dead pigeons on a table in front of a wall with a flaming painting on the right and a large opening into another room in the distance on the left. The still life is unusual. What other still life with precisely these elements comes to mind when we think of the long history of the genre before 1886? The answer is none.

The "dead" elements, the pigeons, are even stranger. We easily identify two, to the left and right of the containers. But looking more closely, we see that there might be an additional white pigeon on which the one on the left leans its head and body, and to the left of this is a pigeon-shaped fold

37 Paul Gauguin, *Still Life in an Interior, Copenhagen*, 1885

in the cloth and the suggestion of yet another pigeon. The oddities persist as we move uneasily into the room beyond. In it, four figures are grouped behind a large chest at the foot of a bed, in which lies a figure whose upper body is cut off "screen." One is a child, who looks out the window into a wintry landscape. Another is a woman, mostly hidden by the music stand of a piano behind the bed, and the two others are wearing hats, as if just-arrived visitors. What are we to make of this social group that is visually accessible but completely apart from the painter-viewer, and, as with much else in the picture, unexplained?

I dwell on these two particular still-life paintings from Gauguin's early career to stress his long-standing aesthetic tolerance for mystery and polyvalent, suggestive meanings. We notice a recurrent slippage of forms and spaces, and a sense that the painted composition deliberately evades our attempts to interpret it or to place it neatly in art history. Both are unique within the class of still-life painting to which they make a contribution, and the same can be said for *Arii matamoe*.

When we remove the Getty picture from the comparatively narrow context of Gauguin's oeuvre and consider it in the larger history of still-life

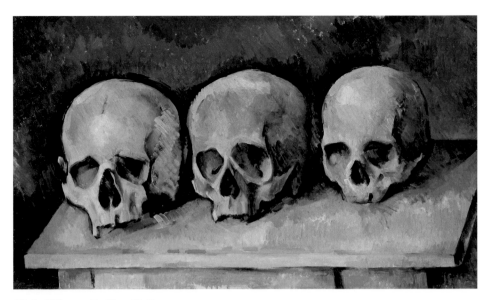

38 Paul Cézanne, *The Three Skulls*, ca. 1900

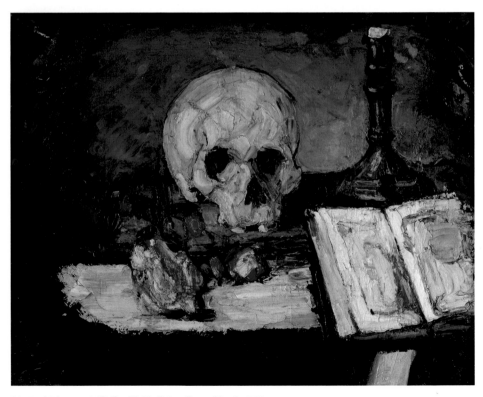

39 Paul Cézanne, *Still Life with Skull, Candle, and Book*, 1866

painting, *Arii matamoe* can be related to a large body of representations dealing with death. Granted, most of these feature skulls rather than severed heads, but it is worth noting that the memento mori still life with skulls and other elements suggesting decay and death was a common feature of the genre, particularly in the seventeenth century. Among Gauguin's contemporaries, Paul Cézanne manifested a pictorial fascination with skulls and death already in the 1860s and continued this focus to the end of his own working life in 1906 (ill. 38).

Gauguin briefly owned an early Cézanne still life with a skull, a snuffed candle, and a book (ill. 39), a painting that he later gave to Camille Pissarro, proving that he had a direct connection to and familiarity with this tradition of the memento mori still life and its revival in avant-garde French art. However, it was not just skulls that interested him but also depictions of severed heads. These were numerous, even ubiquitous, in both seventeenth- and later nineteenth-century art and, thus, very accessible as source material for Gauguin. The head of Saint John the Baptist after its severing ordered by Salome, and that of Holofernes after its severing by Judith, were common; the head of Orpheus also appears with some regularity in contemporary and somewhat earlier still-life paintings known to Gauguin.

However, looking at a particularly beautiful—and as yet unattributed—still life with the head of Saint John the Baptist in the Cleveland Museum of Art (ill. 40), it is easy to see how much Gauguin's royal head departs from tradition. Here, the Italian or Spanish artist presents the head as if *just* dead, showing the marks of its severing and blood on the metal plate on which it is placed. Gruesomeness is precisely the point of the many Renaissance and Baroque representations both of the act of beheading (Caravaggio springs to mind) and of its results—the head on a plate. Interestingly, one of several surviving skulls thought to be possibly John the Baptist's is one of the most famous relics in France, at Amiens Cathedral. As we have seen, Gauguin was capable of layering source upon source for an object in one of his paintings.

The French artist contemporary with and familiar to Gauguin who was most obsessed with severed heads was Odilon Redon, who represented so many of them that it is difficult to choose just one to discuss. Scholars of Symbolism have shown that many of Redon's heads can be traced to Gustave Moreau (ill. 41). Again, the case for a connection is generic; there are no clear sources for a work by Gauguin among Redon's extensive body of works on paper and paintings featuring severed heads. But Gauguin's

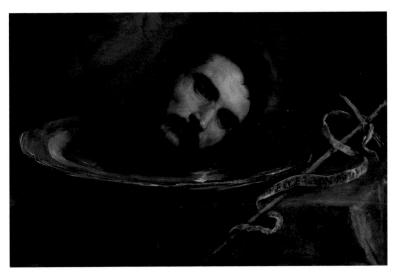

40 Unknown artist (Spain or northern Italy), *Head of Saint John the Baptist*, ca. 1550–1650

written oeuvre reveals much in this direction. In his last book, *Then and After*, he discusses Ary Renan, a French Symbolist painter and the son of the famous Ernest Renan, best known for his controversial book *The Life of Jesus* (*La vie de Jésus*, 1863), whom Gauguin had extensively discussed in an earlier text, *This and That* (*Diverses choses*, 1896–97). It is not so much Gauguin's mention of Ary Renan in his last book that is central as is the young Symbolist painter's own text, *Gustave Moreau*, which was published in 1900, the year Renan died. According to Gauguin, he was introduced to Ary Renan two years before leaving for Tahiti in 1891. This makes an even stronger case for the connection, because *everything* Gauguin wrote has significance. Yet we cannot ignore the fact that Gauguin's texts were never published in his lifetime. The meanings of works like *Arii matamoe* have eluded many precisely because the associations were so deeply embedded in the artist's personal life, or buried in his writings, which have not been widely accessible (more on this later) and, as a consequence, have remained shrouded in mystery.

Let us return to the key concept of this essay: the particular ways in which Gauguin makes his painted subject "beautiful" or evokes beauty as a concept. In this case, beauty is located in what theorists glibly call "the other." Gauguin worked to create an interior setting for this utterly non-Western subject that was at once "authentic," or believable as such,

41 Gustave Moreau, *The Apparition*, ca. 1876–77

and beautiful. The same with his grouping of figures, who activate what
in most cases in art historical still-life paintings is quiet and unpopulated.
It is precisely the beauty of otherness that is the key to understanding
Gauguin's painting. *Arii matamoe* is a pictorial response to a real histori-
cal event witnessed by Gauguin, the funeral of the last king of the Society
Islands, Pomare V (ill. 42), who died in Papeete, Tahiti, on June 12, 1891,
just three days after Gauguin's arrival. Because he was an artist, Gauguin
was reportedly asked to assist with the decorations involved with the
funeral, which took place on June 16 and about which Gauguin wrote
voluminously in chapter 2 of *Noanoa*, the fictionalized account of his Tahi-
tian trip written in the months after he returned to Paris in 1893. I quote
from this passage as translated by Vouitsis for two reasons: the contrast

Designé et se baissa pour prendre
l' ... transparente se tu...

42 Photograph of King Pomare V, reproduced in Henri Le
Chartier, *Tahiti et les colonies françaises de la Polynésie* (Paris:
Jouvet et Cie., 1887), 33

between it and the representation of a royal death in *Arii matamoe*, and
Gauguin's deep feeling of loss—less for a king than for a culture that no
longer existed:

> King Pomare was deathly ill during this time and any day, grief was
> expected to prevail. A peculiar air, however, gradually overran the
> city. The Europeans, whether merchants, civil servants, officers or
> soldiers, continued to sing and amuse themselves in the streets while
> the natives solemnly maintained a quiet vigil around the palace. In the
> bay an unusual amount of activity was taking place: Under the sun,
> orange sails suddenly dominated the blue ocean, reviving the silvery
> stir of the reefs. They were inhabitants of neighboring islands, who
> streamed in day after day to witness their king's final moments and
> France's official reign over their empire. This was predicted by signs

from above, for every time a king dies, dismal masses appear on specific mountain slopes at sundown. According to the natives, this was an impending sign of death.

Indeed, just as nature had predicted, the king passed and was exposed in his palace in an official admiral's uniform for all to see.

A woman who went by the name of Queen Marau was decorating the royal living room with flowers and fabrics. Just as the director of public works asked for my advice in creatively arranging the funerary décor, I directed him to the queen, who with the refined instinct of her Maori race, radiated with grace and transformed into a work of art everything she touched. [...]

All the Tahitians dressed in black and for two days, we sang chants of bereavement, the hymns of the dead. In my mind, I thought I could hear the "Sonate Pathétique."

At six in the morning on the day of the funeral, we left from the Palace. The detachment and its authorities were dressed in black and wore white helmets, while the natives sported their own distinct funerary apparel. All of the districts marched in order and each chief carried the French flag. This made the black mass appear even more dismal.

We stopped at the district of Arua. There stood an indescribable monument, which along with the atmosphere and the vegetation's furnishings, made the most horrible contrast: A mass of coral stones held together with cement. The negro Lacascade gave a speech—a common cliché—which an interpreter also translated for the benefit of the Maori. Thereafter, the Protestant pastor gave a sermon. It was after all this that the queen's brother Tati was finally able to speak and with that, the funeral ended. Everyone left and officials crammed into carriages, as a return to normalcy set in. . . . [...]

With only one less king, everything soon returned to normal: with him had disappeared the last remnants of their customs and ancient majesty. Along with the king's death, the Maori tradition had also died. Alas, civilization had triumphed—militant, professional and bureaucratic.

There is no doubt that Gauguin felt a deep sense of loss when he arrived in Papeete to find a small, provincial French colonial town that had essentially erased all but remnants of what he suspected had been a thriving indigenous culture, whose priestly and aristocratic nature fascinated

him. What survived were the people, most of whom wore European clothes and many of whom, in the capital, preferred to speak French rather than their native language. Not surprisingly, Gauguin found beauty not in the European town but in the bodies and held-over customs of the Polynesians. What the passage, and a good many others in Gauguin's contemporary and later texts, suggests is that he located beauty within the indigenous culture. Unlike "Orientalists," who represent the "exotic" East in ways that are essentially determined by the European West, Gauguin searched not only for exotic subjects but, more importantly, for what he considered the intrinsic beauty of this indigenous culture. For him, the contrast between the royal head in his *Arii matamoe* and Pomare V as represented in official photographs—with his European haircut, pasty complexion, and French quasi-military uniform—was total. Gauguin's account stresses the almost unspeakable ugliness of the funerary monument and locates beauty in the Euro-Polynesian funerary rites, but only in the Tahitians themselves, specifically Queen Marau and her brother Tati. It goes without saying that Tati's funerary words, presumably spoken in the ancient indigenous language, were completely mysterious to Gauguin since he had only just arrived.

As he worked on *Arii matamoe* almost a year later, Gauguin was in the throes of learning the Tahitian language, and was attempting through linguistically accessible European sources to reconstruct the lost culture of the Maori. His first book, *Ancient Maori Beliefs*, was entirely composed from earlier sources, mirroring his larger desire to locate some primordial beauty in a culture, the experience of which, for him, was about loss. The book begins in Tahitian, a language with only an oral tradition. For him, even the sound of the language being read aloud was beautiful, and, as we know from *Arii matamoe*, he wanted that mysterious resonance to pulsate in the minds of his viewers.

To understand Gauguin's intentions in this process of aesthetic recovery, one must turn not only to the works of art but also to the texts he wrote in the decade remaining to him: six manuscripts intended for publication (a seventh was intended for his daughter Aline, and completed in 1893). These texts have always been difficult to access, for two reasons. First, they have long been considered works of art themselves and thus tend to be reproduced in expensive facsimiles, accessible to scholars but not to the larger public interested in Gauguin's ideas. Also, unless one is fluent in French and adept at reading Gauguin's handwriting, they are essen-

tially lost texts. In them, Gauguin writes often about the elusive concept of beauty, the subject of the essays in this volume. He tells his daughter in *For Aline* that it is possible to make a beautiful painting of an ugly subject. The resonance of this with *Arii matamoe* needs no explanation, and, after thinking about its message, it is easier to look again at the utterly beautiful head in a complex, chromatically charged palace interior and realize that Gauguin succeeded at his challenge. The centrality of the idea of beauty in Gauguin's art is most explicit in the brief dedication of his last book, *Then and After,* to the art critic at the *Mercure de France*, André Fontainas:

> All of this and all of that was driven by a subconscious feeling born of isolation and a lack of refinement. This is the story of a wicked, yet at times thoughtful child, who is nevertheless passionately fond of all things beautiful. There exists only one type of beauty, one that is personal and human.

What, we must then ask, is "personal" or "human" about *Arii matamoe*? The answer is not too difficult to find, because it was clearly Gauguin's personal sense of a *lost* beauty and his firm belief that the indigenous peoples lived with one another in a way that, for him, was not "militant, professional and bureaucratic," as he railed above, but human in its very directness and authenticity. When excavating beneath the colonial exterior of Tahitian life for what came before, Gauguin was precisely searching for beauty. And whether, as the title *Arii matamoe* suggests, this Maori dynasty was "dead" or "sleeping," its beauty was revived by the different evocations of Gauguin's imagination.

It was the sense of loss that gave that retrieved beauty its poignancy and power. In creating the paintings of what we might call "immemorial Tahiti," to borrow a phrase from Gauguin's first and most powerful posthumous commentator, Victor Segalen, Gauguin attempted nothing less than to resuscitate a forgotten culture. *Arii matamoe* is part of a larger, collective work of art consisting of about twenty paintings, many prints, a number of printed drawings, and a series of illustrated texts. These were produced to be interpreted as a unified corpus, and, to make his texts as powerful as possible, he sought the advice and active collaboration of a younger poet, Charles Morice.

Morice helped Gauguin assemble the text for his epic *Noanoa*, into which he pasted a black-and-white photograph of *Arii matamoe* on page 59

of the original manuscript. In this sense, we can consider *Arii matamoe* a kind of collage combining Western interpretations of foreign traditions whose full meaning, according to Gauguin, was accessible only by immersing oneself in the culture, as he had. And just as *he* had interrogated everything, *even the silence*, in his quest for answers, we too must look beyond the painting for its meaning and, ultimately, its elusive beauty.

Noanoa contains several lengthy poems that were likely conceived and written by Gauguin with Morice's guidance. They have been routinely discounted by Gauguin scholars simply because Gauguin is not verifiably the sole author. Yet the only extant copy of *Noanoa* was written entirely in Gauguin's hand, indicating that, in his mind, the texts were his. For Gauguin, to borrow a paragraph, a sentence, or a phrase was no different than borrowing a composition or a figure from a work by another artist. He would have laughed had he been accused of plagiarism, largely because he thought that the act of borrowing was itself *personal*. As early as mid-January of 1884, Gauguin wrote in a letter to his first "teacher," Camille Pissarro, that it was precisely because artists looked up to their "masters" that they borrowed from them. Later he expanded the notion of visual translation in his own book of art criticism, *Idle Chatter* (*Racontars de rapin*), dated September 1902.

Gauguin was interviewed by the art critic Eugène Tardieu before returning to Tahiti in the summer of 1895, and portions of their exchange appeared in the May 13 issue of *L'écho de Paris*. It seems that the beauty of his latest works was also lost on most art critics—Tardieu seemed truly baffled, and even asked the artist if the formal oddities in his paintings were intentional. Gauguin replied yes, absolutely. When pressed about his unusual subjects and idiosyncratic manner of depicting them, Gauguin essentially stated (and rather annoyingly for Tardieu, per the transcription!) that he was giving beauty *new meaning* by borrowing from past artists, whether it was understood or not. This is perhaps why he wrote at least six of his seven books, destined in his own mind for publication. Whether he is discussing Giotto, Rembrandt van Rijn, Eugène Delacroix, or the execution of a young man in late 1888, Gauguin's words fill in the gaps that his images leave unexplained in the minds of viewers.

I stress this before quoting a lengthy poem about the death of the gods of Tahiti, a text that is surely an eloquent expression of Gauguin's own profound sense of loss—a loss expressed in *Arii matamoe* as well as in his description of the funeral of Pomare V that inspired it. This poem, given a Tahitian title by Gauguin, as well as all of his poetry in *Noanoa*, has

been translated by Vouitsis. This one appears between chapters 6 and 8 of Gauguin's handwritten text, and seems to perfectly embody the loss of an ancient culture and a modern artist's attempt to revive it, both in words and in the image of a "sleeping" king. I condense it so as to stress the essential elements, but the full version in French (so as to allow those familiar with the poetics of that language to judge its sounds as well as its meanings) is in the note at the end of this essay:

THERE RESIDES THE TEMPLE

On the dreadful summit of the happy islet,
There resides the Temple.
Wide open space, solemn, frightful and barren,
Where rest the feet of Gods holding the weight of heaven.
High atop this peak, with Arorae as its crown,
The lush forest comes to die on the towering mound,
Where the blood of victims spilled ages ago,
And also where the living would piously go.
This ritual for the noble Atuas was once dear,
Who ruled according to their wisdom's depth,
Long ago! the frightening expansion of earth
Justified life by embracing death.

So the Island was big and its people were strong,
Preserving on this bloody site where the sun burns,
The secret to relish in the pure bliss
Of diving body and soul in a vital wave of pain:
This was the era when nobility reigned.
Long ago Tahiti rejoiced in the light,
The true daughter of the waters, lush and proud,
In whose blood the sacrificers lavishly relished. [...]

The Gods are dead, Tahiti dying with them and
The sun long ago which gave life now kills it,
Its sinister sleep only bringing brief visions of hope:
The tree of Lament is then reflected in the eyes of this *Eve*,
Who wondering, smiles, while searching deep in her soul,
But sterile she remains, sealed by divine aims.

The Gods are dead, but when on its chariot of gloom,
Crimson with love and famous for doom, the night
appears chasing the furious sun,
The Gods rise from their graves,
Who, on the peak in a secret summit
remain static throughout the night,
their arms reaching out to the sea. [...]

"It is the hour of Gods, the night of Gods, twilight!
Come you must serve them, it is you they've elected.
It is the night of Death and Love, not day!
Come you must serve them, it is you they crave." [...]

"Nothing will bloom under the palms,
Where life has faded in our dead hands.
The living who worshipped him under the palms,
Did they know to nurture your cherished flesh?"

"Your blood is condemned, the time has come,
When man must die, never to live again."

"The Gods are dead, the time has come,
When man must follow in the night without end.
So that the God Taa'roa's successor,
May nurture the eternal seed once more,
So that the God Taa'roa's conqueror,
May share with those bigger than man the world." [...]

"Come, it is you the dead Gods have chosen,
In the Temple where the nude lays there,
Come, with the candor of your youth wide open,
With the pride of your beauty laid bare."

"You cannot escape the devotion of the Gods,
They will seize you precisely for your charm,
Vairaumati is your name, the lover of Gods,
Or else, despite your tears ... you'll become their prey."

"It is the hour of Gods, the night of Gods, twilight!
Come you must serve them, it is you they've elected.
It is the night of Love and Death, not day!
Come you must love them, it is you they crave."

And in terror the child sees the ancient sanctuary,
this Temple of rituals, this mortuary,
and the dreadful Gods with their sacred speech,
throwing their bloody arms up to a dead sky. [. . .]

The child sees and already the time has come:
Man is dead: He has died never living again.
The Islands and Seas now serve a new Master,
greater than the last, whose eyes are like buds of light,
He is perfect and the child smiles at him through her tears.[1]

To read this is to immerse oneself in a complex, layered, and logically elusive narrative with dead gods (who seem, paradoxically, alive), ravenous and lively spirits, and beautiful, genderless creatures whom the dead gods crave. Who, we ask, is "you"? The reader? The beautiful youth? The child? The entire race of Polynesians? Or some combination of these, assuming one identity in one part of the poetic text and another later on? And, in this nocturnal landscape of pagan death, what are we to make of the presence of Eve as well as her mortal nemesis, Vairaumati, who according to Maori beliefs immaculately conceives the god Oro's son? Was Gauguin describing a Tahitian paradise whose sterile Eve was succeeded by another goddess? Or was he also recounting the death of an ancient culture at the hands of a new one?

The loss of a culture, and Gauguin's elusive words expressing its past without evoking symbols familiar to a Western reader, represent a death perhaps even more cruel than one inflicted by a guillotine. Yet this very foreignness was the whole point of Gauguin's revival of Tahitian history in the form of poetry, since hymns and laments formed the basis of the Tahitian oral tradition. The decapitated head in *Arii matamoe* is therefore a metaphor of loss and the ability of art to revive what is dead.

For Gauguin in Tahiti in the early 1890s, beauty was found only in the lost civilization of the Maori and in the bodies of Tahitians whom he saw, spoke with, and loved. This beauty is, in many senses, as "modern" as that

of Manet, with his obsession with the world of fashion and the evanescence of time. Gauguin's beauty was immemorial and, paradoxically, dead, and it spoke from the lips of a dead king's dismembered head. It spoke through the sounds of bamboo flutes in other paintings and through his *Vivo* poems. It spoke through words that had never before been written in European script—the words of Gauguin's Tahitian titles and texts. Gauguin's beauty was translated from a lost original and could never quite be grasped. His royal head, preserved against time, existed in his imagination and exists for us in his fictive world as painted and written. *Arii matamoe* is, fundamentally, as elusive as Manet's *Jeanne*, and although we are confronted by the cruelty of the human remains on his canvas, Gauguin found that the horrors of this lost civilization were indistinguishable from its beauty.

NOTES

1 All the passages quoted from Gauguin's texts were translated by Elpida Vouitsis, my colleague at the O'Donnell Institute of Art History at the University of Texas at Dallas. I thank her for allowing me to publish these excerpts. Her tireless work of translating all of Gauguin's texts into English for the first time took five years and has revealed much about the artist's entire Tahitian and Marquesan period, some clues going even further back to Gauguin's art from the 1880s. The poem "There Resides the Temple" appears in the original *Noanoa* text on pages 117 to 123, transcribed here by Vouitsis (the punctuation, markings, capitalization, and underlining are Gauguin's):

PARAHI TE MARAE (LÀ RÉSIDE LE TEMPLE)

Sommet d'horreur de l'Ile heureuse, là réside
Le Temple, lieu ouvert, morne, sauvage, aride :
Là sont les pieds des Dieux qui supportent le poids
Du ciel; là vient mourir la richesse des bois.
Tout en haut de l'Arorai, cimier des cimes;
Là coulait Autrefois, le sang pur des victimes
Où les vivants communiaient pieusement :
Et ce rite était cher aux Atuas cléments
Qui gouvernent selon leur sagesse profonde –
Autrefois! l'effroyable expansion des mondes
Pardonnaient à la vie en faveur de la mort.

Alors l'Ile était grande et son peuple était fort,
Gardant du lieu sanglant où le soleil flamboie
Le secret de goûter une virile joie
À se plonger l'âme et le corps au flux vital
De la douleur. Ce fut le beau temps féodal.
Autrefois! Tahiti riait dans sa lumière,
Fille franche des eaux, délicieuse et fière,
Qu'enivraient de son sang les sacrificateurs.

Et de honte l'ardeur du ciel sur les hauteurs
Horribles, Taroa que l'Univers contemple
Entretenait la flamme homicide du temple
Où venaient les héros allumer leur vertu.

Or, voici que le cri des victimes s'est tu
Dans le temple, et partout dans les langueurs de l'Ile
Cœurs de mâles et flancs de femmes sont stériles.
La prudence égoïste et l'épargne ont tari
Le sang dont le sommet sacré n'est plus fleuri
et qui stagne aux longs bords des siestes énervantes
et la vielle Fôret dont la sève fervente
S'enrichit de s'épandre en flots insoucieux -
Palmiers fins dont le front s'agite dans les cieux,
Tamaris, hibiscus, fougères gigantesques,
Lianes sinuant leurs souples arabesques,
L'arbre de rose et le mango qui chargent l'air
D'un faste d'ombre et de parfum, l'arbre de fer
Et ceux qui prodiguent leurs doux fruits – boissons crèmes
Et Viandes et pain, et ceux qui, se donnent eux-mêmes –
Murs et toits des maisons, barques, foyers et lits, -
Font de vivre un joyeux songe où sont abolis
Le labeur et la faim, la misère et l'envie.
La Fôret toute entière où bout l'immense vie
(Perpétuel trépas : renaissance sans fin)
Dénonce et blâme avec le tumulte divin.....
De l'Amour l'œuvre impie et menteuse de l'homme
Qui s'égare aux détours de calculs économes
S'empoisonne du sang qu'il refuse aux autels
Et croulant dans la mort se proclame immortel.

Vers la cime des Dieux, déserte et diffamée
Où ne s'essore plus en gloirie la fumée
Du sang et de l'encens, seul monte, humble et profond,
L'hommage des aïeux de la Fôret, qui font
Avec leurs frondaisons tremblantes dans la brise
Un geste d'encensoir vaste, qui s'éternise.

Vers le rivage ému de frissons argentés
Rit et chante, aime et dort toute une humanité
Puérile et folâtre, oublieuse et frivole,
Rayonnante au soleil, comme les vagues, molle
Et jouissant du jour tant qu'il luit. Iméné!
Glas de la vie! Écho du passé profané!
Chant immémorial de gaité démentie
Par la menace dans l'air lourd appesantie!

Les Dieux sont morts, et Tahiti meurt de leur mort.
Le soleil autrefois qui l'enflammait l'endort
D'un sommeil triste avec de brefs réveils de rêve :
L'arbre alors du Regret point dans les yeux de l'EVE
Qui pensive sourit en regardant son sein,
Or stérile scellé par les divins desseins.

Les Dieux sont morts mais quand sur son char de Ténèbres
Le soir pourpre d'amour et de meurtre célèbre
apparaît pourchassant le Soleil furieux
Du fond de leur tombeau se relèvent les Dieux
Qui, sur la cime, en un mystérieux concile
Durant toute la nuit demeurent immobiles,
Les bras dardés vers la mer. Et du haut du mont
vers la mer lentement essaiment les démons
Tupapaus, Esprits des Morts, larves cruelles

Et dans l'étroite case en repliant leurs ailes
Vers la couchette où la Peureuse ne dort pas.
Se glissant, froids frôleux et chuchotent tout bas :

C'est l'heure des Dieux, c'est soir des Dieux, c'est soir!
Viens: pour les servir c'est toi qu'ils ont élue.
C'est soir de la Mort et de l'Amour, c'est Soir!
Viens: pour les servir c'est toi qu'ils ont voulue.

Tu n'iras plus jouer au bord de la mer
Et chanter l'iméné sous les lauriers roses
Fondre l'or de ton corps à l'or de la mer
Baigner ton rêve au vague rêve des choses.

Adieu la brise qui baisait tes cheveux
Pendant la sieste auprès du ruisseau qui chante
Adieu la fleur qui riait à tes cheveux
Pendant que tu dansais sur l'herbe odorante.

Rien ne va plus fleurir sous les pandanus
Où déjà meurt la vie entre nos mains osseuses :
Les vivants qui l'aimaient sous les pandanus
Ont-ils su féconder ta chair amoureuse?

Ton sang est condamné, le temps est venu
Où l'homme doit mourir pour ne pas revivre.

Déjà les Dieux sont morts, le temps est venu
Où l'homme dans la nuit sans fin doit les suivre :
Afin que l'héritier du Dieu Taora
Couve à nouveau l'œuf de l'éternel Mystère
Afin que le vainqueur du Dieu Taora
Partage à de plus grands que l'homme la Terre.

Et comme une femme était au premier jour
De qui procéda la vie et l'Espérance.
Qu'une femme aussi se lève au dernier jour
De qui vienne la mort et la délivrance.

C'est toi que les Dieux morts ont choisi : Ô viens
Au temple nuptial où tonne la nue
Avec la candeur de ta jeunesse, ô viens
Avec le pur orgueil de ta beauté nue.

Tu n'échapperas à l'amour des Dieux,
Ils te possèderont dans ta juste joie,
Vaïraumati, amante des Dieux,
Ou tu seras malgré tes larmes leur proie.

C'est l'heure des Dieux, c'est soir des Dieux, c'est Soir!
Viens : pour les servir c'est toi qu'ils ont élue.
C'est soir de l'Amour et de la Mort, c'est Soir!
Viens : pour les aimer c'est toi qu'ils ont voulue.

Et l'enfant voit dans sa terreur le sanctuaire
Antique, l'appareil des rites mortuaires,
Les formidables Dieux au verbe inviolé

Dardant leurs bras sanglants dans le ciel désolé.
Et sa race au grand cœur qui lentement succombe
Sous le pesant remords dont l'opprime la tombe
Où l'attendent les Dieux qu'elle a mis en oubli :
Sommet d'horreur de l'Ile Heureuse, là réside
Le Temple, lieu ouvert, morne, sauvage, aride.

L'enfant voit et déjà les temps sont accomplis :
L'homme est mort. Il est mort pour ne jamais renaître.
Les Iles et les Eaux servent un nouveau Maître,
Meilleur, et dont les yeux sont des clartés en fleur.
Il est beau et l'enfant lui sourit dans ses pleurs.

43 Paul Cézanne, *Young Italian Woman at a Table*, ca. 1895–1900

IS BEAUTY BEYOND TIME?

PAUL CÉZANNE'S *YOUNG ITALIAN WOMAN AT A TABLE*

To write about Paul Cézanne is a persistent challenge, for two reasons. First, his art is held in such esteem by critics and historians of modern art, as well as by artists, that writing about it is too often an act of hagiography rather than analytical art history. Second, and more importantly, we know so little about him. The contrast with Manet and Gauguin in this latter respect could not be greater. When I write about Manet's *Jeanne*, I can say with confidence when it was painted, where it was exhibited, what it was titled, and what contemporary viewers thought of it. With Gauguin, the detail is even greater, largely because, unlike Manet, Gauguin wrote a good deal, so that we can add his own words to the prodigious historical and circumstantial evidence about him and his oeuvre. For Cézanne, however, we have little to go on. He didn't title his own paintings, or date them, or sign more than a small percentage of them. He didn't write more than a few sentences about art in his letters. His works were shown in a handful of exhibitions (just three of substance) during his lifetime, and the works *in* those exhibitions are not easy to identify conclusively. The writings about him by contemporaries tend to have been penned in the last five years of his life, and many of them are thought by art historians today to be unreliable as historical evidence.

So, we are left with the art. I have chosen, as the subject of the last investigation of the nature of beauty in three works of modern art at the Getty Museum, one of Cézanne's most important late figure paintings (ill. 43). When searching the immense literature about Cézanne written in the twentieth and twenty-first centuries, we confront a bewildering variety of "facts" about this work. Physically, we know what it is. But what is its subject, and when was it painted? The answers might surprise you with their very vagueness and variety.

Subject first. We can see that it features a woman in some sort of costume alone in an interior, with her head resting on her right hand, and her right arm resting in turn on a table covered with a heavy printed fabric or perhaps a small carpet. Her left arm is bent at the elbow, although its

length and form are obscured by a billowing white sleeve, and her left hand also rests on the table. We know her gender, approximate age, and pose, but we must look to the written history of the painting to tell us more about who she is and what she might signify.

I will now list all the titles that the painting has had in its long history of publication: from 1923, *Jeune Italienne accoudée* (Young Italian woman leaning; *accoudé* is hard to translate because the adjective includes a body part, *coude*, or "elbow"); in 1927, *Frauenbildnis* (Portrait of a woman); in 1928, *Femme accoudée* (Woman leaning); in 1929, *Portrait of a Girl*; in 1936, *Portrait de femme accoudée* (Portrait of a woman leaning) and also *L'Italienne accoudée* (The Italian woman leaning); in 1937, both *Young Woman Resting* and *Young Italian*; in 1944, *Leaning Woman*; in 1948, *L'Italienne*; in 1956, *Junge Italienerin* (Young Italian woman); in 1967, *Italian Girl*; in 1990, *Young Italian Woman*; and in 1999, when it came to the Getty, *Young Italian Woman at a Table*. We see here a conundrum of description: Is she a woman or a girl? Is she French or Italian? Is she leaning or sitting? Is this a portrait of a specific woman, or a model painted as a generic woman? Cézanne is mute on this subject. And the dates that have been assigned to the work in the published literature are likewise bewildering in their variety: 1888, 1896, 1893–96, circa 1895, 1897, 1896–99, circa 1900, 1900–1904, and 1895–1900. What we infer is that, according to Cézanne scholars and curators, the unsigned and undated painting *could* have been made anytime in a period spanning more than fifteen years. Contrast this to the situation in which we know *precisely* when Manet (shortly before the 1882 Salon) and Gauguin (the months before June 1892) painted their works already discussed, which allows us to embed our understanding of the art in the lives and experiences of the artists.

Simply typing that last sentence made me realize just how much works of art, and their beauty, are "of their time" and "of their place." Even in the great museums, time and place (often place more than time) dictate the physical situating of works and, thus, the visual context in which they are beautiful. Early museums divided "Italian Art" into "schools" defined by geography—Florentine, Sienese, Roman, Venetian, and so forth—so that we would never find a Raphael with a Titian, or a Rembrandt with a Caravaggio. Rarely do we encounter important works of past art in the direct company of works produced in different centuries or countries. Thus, in art history, beauty is *located* in time and space.

What Cézanne succeeded in doing, seemingly intentionally, was to remove his works of art from particular places and times by generalizing and simplifying details that would be specific to a place or time. Thus, his works have slippery temporal and physical contexts, and scholars who write about them, particularly the figure pictures, even the most famous of them, struggle to identify their place of execution. Is our untitled painting of a woman in a close interior in Paris or Provence? Is she Italian or French? What she is *not* is fashionable like Manet's *Jeanne*, who could almost be a poster girl for France in the spring of 1881. Was Cézanne's model painted in the late 1880s, when the artist is thought to have made a series of ambitious figure pictures rooted in art history? Was she shown in the 1895 exhibition at Ambroise Vollard's gallery and, thus, seen by the who's who of collectors, critics, and artists? Was she painted at the very end of the artist's life? The experts disagree, and not one of them has more evidence than another.

Let's deal with the woman's identity first. Since 1936 she has been characterized persistently as an Italian model who was related to a known Italian model in Paris, one Michelangelo di Rosa. Cézanne painted Michelangelo several times in the late 1880s (according to some sources) and during the early 1890s (in others), and he appears in a series of pictures with titles like *Boy in the Red Vest* (ca. 1889–90, ill. 44). The exact relationship (sister-brother, aunt-nephew, mother-son, cousin-cousin) between the two is not clear, and if they *were* related, she was considerably older. The persistence of the identification does not in itself prove that it is true, but it is not unlikely. What it does suggest is that our painting in question was made in Paris, where Cézanne had access to such models and, after the death of his father, in 1886, funds to pay them.

One of the principal sources of disagreement among Cézanne scholars is over which pictures were painted in Paris or elsewhere in the north of France, and which in Aix or the Provençal countryside, where the artist was born and maintained a residence until his death. Cézanne often painted what might be called generic, non-locative landscapes. He tended to avoid landmarks. The great historian of Cézanne, the late Françoise Cachin, struggled with this in many of her eloquent work-specific essays for the artist's latest major monographic exhibition, held in Paris, London, and Philadelphia in 1995–96, attempting, for instance, to identify the settings for important figure paintings like the Musée d'Orsay's monumental *Woman with a Coffee Pot* (ca. 1890–95, ill. 45). The Getty Cézanne was not yet

44 Paul Cézanne, *Boy in the Red Vest*, ca. 1889–90

45 Paul Cézanne, *Woman with a Coffee Pot*, ca. 1890–95

owned by the Getty when that exhibition was organized, and its location was unknown to the curators. Thus, it didn't appear in the most important context in which it might have been placed and dated through connections to other works, and, because it is now deemed too delicate to travel, it was not included in the recent exhibitions *Cézanne in Paris*, held at the Musée du Luxembourg in 2011–12, and the current *Cézanne's Portraits*, presented at the Musée d'Orsay in Paris, the National Portrait Gallery in London, and the National Gallery of Art in Washington, DC.

I stress this issue about *where* the work was painted because it relates to the evocation of two different kinds of beauty: one urban and high-culture, the other rooted in a provincial landscape with its own independent history and culture. For Cézanne, these two worlds were experienced in alternation over the last fifteen years of his life. After his father died in Aix, Cézanne gained access to considerable capital. Hortense Fiquet Cézanne, Cézanne's wife, was not from Provence (the couple met in Paris), and was more comfortable living in the city. For that reason, and to have access to the museums and neighborhoods of the capital and its powerful art world, between 1888 and 1900 Cézanne successively rented eight apartments and studios in Paris so as always to have a home base there. The range and variety of the apartments, recently visited and described by the brilliant researcher-sleuth Isabelle Cahn, were remarkable. Most of them had four to six rooms so as to comfortably serve two functions, as living space and studio. We learn from writings by the voluble dealer Vollard that Cézanne painted from eight in the morning until lunch, then went out in the afternoon to walk, look at art, and draw. If the sitter in the Getty painting is a professional model, she would have posed for Cézanne, like her relative Michelangelo di Rosa, in Paris. Unfortunately, Cézanne didn't include enough details of the room to allow us to identify it as one or another of his apartments. As I mentioned, this sort of ambiguity was the rule for Cézanne, suggesting that precision of time and place, so important for his Impressionist friends, was anathema to him. "Ars longa," he seems to say, after the Latin expression "ars longa, vita brevis," originally derived from Greek (ὁ βίος βραχὺς, ἡ δὲ τέχνη μακρὴ), meaning "Life is short, and art long." Cézanne read both Greek and Latin with some fluency.

With this as a segue, it is time to consider the art historical resonance of this and other late studio figure paintings by Cézanne. If we imagine the artist painting in the mornings, then looking at other works of art and, in Paris, surveying urban scenes in the afternoon, we can easily identify

an array of art historical precedents that informed his painting. Cézanne sketched older works of art obsessively, and it is perfectly possible that the surviving sheets are only a fraction of his actual production. Unlike Gauguin, he is not known to have amassed a collection of photographs of favorite works of art, most likely because he was often in Paris, where he could visit his favorites again and again.

The process of artists looking repeatedly at earlier works is a complex one, and difficult to discuss with the kind of clarity that "evidence" provides. And little is known about the nature of an artist's visual memory, and how memory and the direct experience of painting from life interact, the latter being Cézanne's mode of working. When he "arranged" his model's pose, made decisions about her costume (was Madame Cézanne present?), and decided upon his props—the table, patterned fabric, and chair, in this case—was he responding to an *idea* of studio figure painting derived from other works of art?

The answer is undoubtedly yes, but which works, and how did he know them? To give more direction to our search for art historical resonance with the Getty Cézanne, we could look at what earlier scholars have articulated. In 1952, Meyer Schapiro, the great historian of Romanesque and modern art, wrote the single longest descriptive analysis of this painting, in which he stated that "the whole is treated with a breadth that recalls the great Venetian portraits of the Renaissance." This guides us to think of the portraits of important men and women by Titian, Giorgione, Tintoretto, and others in museum collections throughout Europe and the United States. The fact that Schapiro linked this work with portraits is telling, because portraits mostly lack complex allegorical or literary allusions or "meanings," and we generally respond to them as exercises in composition and color in which even the identity of the sitter is secondary. Many old master and modern portraits are known today as *Portrait of a Man* or *Portrait of a Woman* since when they entered the art market in the eighteenth or nineteenth century, they were valuable because they were painted *by* someone rather than because they were *of* someone. So too with Cézanne's works.

Whereas Schapiro made allusions to portraits from the Venetian Renaissance in generic terms, later art historians found more telling allusions to images of melancholia extending from Albrecht Dürer through seventeenth-century Baroque painting. Although few make direct links to Dürer's great engraving *Melancolia I* (1514, ill. 46), the idea that Cézanne

46 Albrecht Dürer, *Melancolia I*, 1514

was capturing a moment of profound introspection and inertia surfaces
in several of the most powerful descriptive analyses by such art historians
as Theodore Reff and Elizabeth Cowling. Ever since Dürer's seated angel
with her head resting on her hand supported by her upper arm and elbow,
the image of melancholia has been associated with leaning, as if the head
is too heavy to support itself without assistance, most likely because the
idea of a burdened mind carries with it physical implications of weight. The
words "melancholy" or "melancholic" appear often in scholarly discus-
sions of Cézanne's painting, and it is worth spending a little time investi-
gating the nature of these links and the ways they affect our reading of the
painting and its modes of beauty.

47 Lucas Cranach the Elder, *Melancholy*, 1532

The trick here is to separate images of women leaning and of a head resting on an elbow *without* any links to the theme of melancholia from those for which this association is explicit, many of which derive from Dürer's widely known print, whose subject or title is included in the print rather than attached to it by tradition. Lucas Cranach the Elder continued this trend (ill. 47) in paintings in which he borrowed the seated winged figure but created radically different contexts for her, where melancholia is alone with various objects that seem to have provoked her sorrowful condition.

Melancholia is also not necessarily embodied as a woman, and other artists, even in modern art, for instance, Edvard Munch in some paintings and prints (ill. 48), treat the figure as a young man with his head in his hands. Certain images of melancholia link the figure with a skull, most famously Hendrick ter Brugghen's (ca. 1627, ill. 49), and Cézanne himself painted a young man similar in pose to the Getty's *Young Italian Woman at a Table*, his head leaning on his hand with his elbow on a table, contemplating a skull in a picture so redolent of art history that it almost defies its classification as "modern" (ill. 50). We know that Cézanne was widely read in both classical and contemporary literature, and that he looked as much at old master paintings and sculptures as he did at contemporary art. This sense of what we might call "thick" time, a time that encompasses a long duration of form making and imagery, is essential to our understanding of

48 Edvard Munch, *Melancholy*, 1894–96

49 Hendrick ter Brugghen, *Melancolia*, ca. 1627

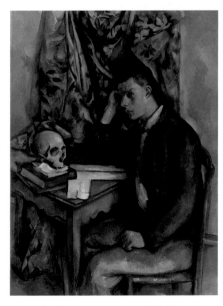

50 Paul Cézanne, *Young Man and Skull*, ca. 1896–98

the Getty painting. The link with melancholia itself is not precise enough to prove a connection with any direct source in the earlier history of art. Cézanne was anything but pedantic and deliberately avoided direct citations of any kind: as with other aspects of the painting, if he was invoking representations of melancholia here, he was referencing them only as a broad tradition.

So, before decisively locating Cézanne's idea of beauty in the state of mind called melancholia, let's step back from art history and see whether the most articulate apologist for the formal beauty of the painting, Meyer Schapiro, can convince us of his approach. His descriptive analysis focuses on the picture's compositional, volumetric, and chromatic qualities, which, for him, suffice. After beginning with his evocation of Venetian Renaissance portraits, he continues:

> The bent figure fills her space grandly. It is a powerfully constructed work, compact with clear parts beautifully fitted to each other and to the canvas surface. The tilted mass of the upper body, with right angle at the elbow, is opposed to the rectangular masses of the skirt and drape. Yet the vertical and horizontal rarely come to view, and then only in short segments, as in the bracelet and the wall.
>
> The most stable masses are covered with lines and spots of un-architectural quality—diagonal, crossed, or curved on the draped table, convergent on the skirt—a typical device of Cézanne's later art, by which the severity of the construction is softened and opposed qualities are interjoined. The color is very rich and strong. The simplicity of the large aspect conceals at first the variety of the color relationships that have been employed.
>
> Consider only the dark blue of the skirt, which has a different kind of contrast with each of the large areas of colors. Its darkness or low value is opposed to the white; its coolness to the warm complementaries of yellow and orange in the fichu [shawl] and the face; its uniformity or evenness to the mottled color of the drape; its purity to the mixed, neutralized brown of the wall. At the same time, the blue mass is harmonized with all these distinct, opposed fields.
>
> Its convergent stripes reappear in the white sleeve, which is also toned with blue and gray. Dark blue lines mark the contours of the face and features and the right arm, and there is blue, gray, and black in the fichu. It is tied to the wall not only through vague green and

purple tints within the brown and through the lines of the wall and the dado at the left, but through the dark key, there is a progression from the skirt to the purplish dado to the upper wall. And last, the blue area is related to the tablecloth, through its similar position and shape, and also to the analogy of lines. Touches of red and green bind the face to the decoration of the drape.

In the analysis of the color, I have ignored equally important aspects. For example, the position and order of these colors, which have expressive sense. The warmer, closer, more intimate range being in the left half of the picture, the side of reverie; and the cooler, but more powerfully contrasted elements on the right half, the side of the body. Beautiful too is the refinement with which Cézanne has related the varied inclinations of the large masses in a depth without horizontal planes.

The succession of overlapping tilted surfaces between the picture plane and the wall is an exquisite thing. Another subtlety is the handling of the vertical and nearly vertical directions in an unmarked band from the upper wall to the right side of the drape, passing through the head and fichu. I must mention finally, the wonderful modeling of the head, with its strong accents of the brush, thickly painted blue lines, very considered and very precise, which give a sculptural firmness to the contours.

Schapiro writes with uncommon eloquence and formal clarity, translating Cézanne's composition and spatial arrangements of form into clear, almost passionate language. Once he even uses words tied to our theme ("beautiful too is the refinement"); later he tells us of another "exquisite" formal quality, which invokes a specific structural "subtlety"; and, finally, he refers to the "wonderful modeling of the head." These value words build as he concludes his rather cooler descriptive analysis. Nowhere does he discuss the woman herself, her age, the possible associations of her pose, or her mood, although he does refer once to the left side of the picture as "the side of reverie." And nowhere does he speculate about where the picture was painted or how it relates to other works in the history of art known to Cézanne. It is the compositional adjustments and the special interplays of formal aspects that hold his attention.

Contrast this with the later commentators. Theodore Reff writes, "A dark flickering spirituality reminiscent of Baroque painting, and especially

of Rembrandt, pervades this work, an image of melancholic lassitude, leaning far to one side, as she supports her head with her hand and braces her body with the other." His concluding words about this painting are that it is deeply melancholic. Elizabeth Cowling, in a 1990 exhibition catalogue, writes about how Cézanne looks forward to classicism in the art of Pablo Picasso, Fernand Léger, and Giorgio de Chirico in the years 1910 to 1930: "*Young Italian Woman* possesses the profoundly meditative silence and stillness of such great portraits as the portrait of Ambroise Vollard and the *Woman in Blue*." And the anonymous author in the most recent Getty handbook remarks, "Although the woman's physical presence is compelling, her withheld thoughts and emotions create a mood of profound melancholy." It is the history of art reverberating through the painting that fascinates these later writers, who almost seem to take its formal qualities for granted. Erwin Panofsky's "iconography" is behind this, of course, but without Panofsky's characteristic precision. No particular work is evoked in any of these evaluative descriptions—neither a work painted before the Cézanne nor one painted after. Only the names of artists: Rembrandt before, and Picasso, Léger, and de Chirico after (an odd trio, to my mind). But does Rembrandt really suffice here?

Looking to Rembrandt's paintings of single female subjects, we find many parallels in tonality and mood, but not in pose or composition. Indeed, the links are generic enough that they are difficult to prove with the documentary exactitude art historians prefer. Yet we cannot reject them altogether, because certain paintings by Rembrandt do evoke the *idea* of an isolated figure in a simple, dark space. Cézanne would have often come across the famous 1654 painting of Rembrandt's wife as Bathsheba (ill. 51) and the late self-portrait of 1660 (ill. 52) in his perambulations through the Louvre, such that in the Getty painting he wasn't quoting a pose or a particular work of art but evoking a general sense of timelessness.

It seems extremely likely to me that, in creating a painting as much about a sleeve as about its wearer, Cézanne was thinking of the most famous sleeve in Western art—the one in Raphael's portrait of Castiglione in the Louvre (ca. 1514–15, ill. 53). When we put the two pictures together, the differences between them overwhelm the similarities, but we mustn't be too quick to discount the vague associations, because Cézanne was seeking the generic, not the particular, to create a beauty that knows no single source and is not, hence, easily defined. There are many northern Baroque figure paintings (either genre scenes of isolated women or

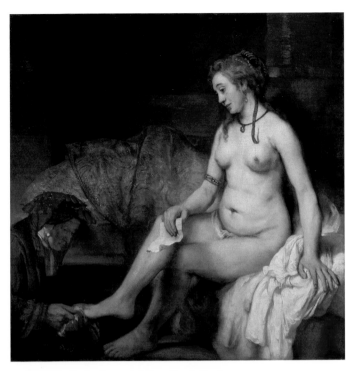

51 Rembrandt van Rijn, *Bathsheba at Her Bath*, 1654

52 Rembrandt van Rijn, *Self-Portrait at the Easel*, 1660

53 Raphael, *Balthazar Castiglione*, ca. 1514–15

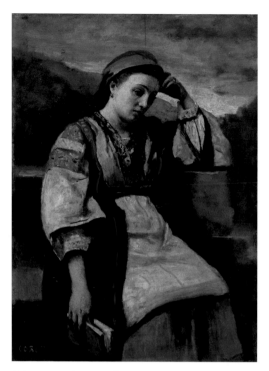

54 Jean-Baptiste-Camille Corot, *Reverie*, ca. 1860–65

portraits in which the female sitter is posed in an imaginative manner) that Cézanne evokes with the same ease and generality as he does the Raphael portrait of Castiglione. As he moved through the Louvre, sketching from its works of art, he might just as easily have found a figure, or aspects of drapery or pose, in a large multi-figure composition that appealed to him. When painters are "on the hunt" in a great museum, they often search for solutions to formal, chromatic, and compositional problems in ways totally unlike those of art historians.

Françoise Cachin, in her placement of Cézanne in art history, tended to discount the temporally distant links to Baroque art, preferring to root his figural materiality in the art of his immediate predecessor, Gustave Courbet. When confronting the volume and formal weight of Cézanne's figure pictures from the last two decades of his life, one can see her point. But, to me, it is less Courbet than his gentler, subtler, older colleague Jean-Baptiste-Camille Corot who springs persistently to mind when seeking the most powerful art historical resonance with the Getty Cézanne. When Corot died in 1875 there was a great exhibition of his work, which Cézanne

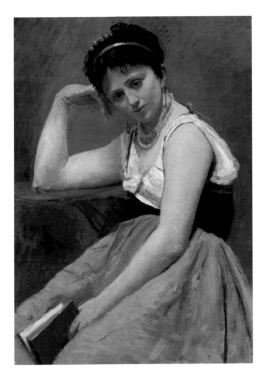

55 Jean-Baptiste-Camille Corot, *Interrupted Reading*, ca. 1870

and his Impressionist colleagues almost certainly saw (he was in Paris that year). And there were several later occasions on which studio figure paintings by Corot, little known in his lifetime, were accessible to Cézanne, in particular a major centenary Corot exhibition held in Paris in May and June of 1895, again when Cézanne was in the city. The paintings by Corot of isolated women posing in costume in the artist's studio (ill. 54) are, in many ways, the works from art history that most resemble Cézanne's own studio figure paintings from the end of his life. Both artists tended to costume their sitters so as to evoke a generic past, often with suggestive links to the Italian or French countryside. Both posed their sitters evocatively so as to make "figure pictures," not portraits.

Again, as in every other case of precedent, the connections are generic rather than particular. But one of the most resolved of these works, a signed painting of almost identical dimensions and ambitions as the Getty Cézanne, is "beautiful" in remarkably similar ways (ill. 55). It is also known by various titles, such as *La belle romaine* (The beautiful Roman woman), *Femme romaine* (Roman woman), *La rêverie* (Reverie), and its current

title, *Lecture interrompue* (Interrupted reading), and it too is given varying dates. The painting shows a costumed female model, seated (though no chair is visible), with her head resting on her right hand and elbow, while a book dangles in her left hand, unread, its pages held open by her finger. Thus, she has two characteristics of "melancholia"—her head resting on her hand and an unread book—without quoting any earlier work with sufficient preciseness to identify a source. Like Cézanne, Corot is in complete control of a painting that is, in ways similar to the later artist, as much about the process of painting as it is about the imagery. The first writers who dealt explicitly with *Interrupted Reading* talk about it in ways that are remarkably like the writers quoted above who attempt descriptive analyses of the Getty Cézanne. The sense that the painting is a representation of the performance of painting itself links them. Writers note how much Corot wanted us to see the adjustments he made to the earrings, the comb, the arm, the book, the skirt, et cetera, and, perhaps because of this, Alfred Robaut, the distinguished cataloguer of Corot's work, referred to the picture as an ébauche, or painted study, in spite of its evident signature. This very idea of "painting as process" is easily located in Schapiro's lengthy description quoted above.

The difference between the two artists lies in their use of color. Cézanne's painting is a full-throated cry of blues, greens, reds, yellows, browns, and whites. The drama of its chromatic interactions is stressed in Schapiro's description. This is scarcely the case with Corot, who confines his palette to browns, beiges, and whites, enlivened by limited reds employed as accents in the hair, jewelry, bodice, and, more subtly, in the table covering and the book cover. While Corot tends to emphasize value (light and dark) over hue (color), Cézanne does the opposite, creating dramatic pictorial tensions via strong and contrasting hues. Each picture allows white to play a dominating role, though in works with rather different palettes.

While it is possible that Cézanne saw this picture in the large posthumous Corot exhibition in 1875, the sheer duration between this sighting and the execution of his own picture makes a direct link unlikely. Again, what persisted was the *idea* of Corot's studio pictures, with their isolated female figures and with their connection to this kind of painting in museum art of the Renaissance and Baroque eras, particularly in Titian, Raphael, and Rembrandt. The Corot and the Cézanne walk a well-trodden art historical path of which each artist had deep knowledge—and, because of the depth of this knowledge, no need to quote from particular paintings.

In discussing the beauty of the Getty Cézanne, I have tended toward its "Parisian" and "art historical" roots, accepting the traditional view that its sitter was a paid model who worked for other artists in Paris, and whose role in the picture was professional and utterly urban. In doing so, I have underplayed the Provençal aspects of the painting's beauty—those that trend away from Paris (as did its maker; more on this in a moment). The Cézanne scholar Nina Maria Athanassoglou-Kallmyer and other writers have commented on the Provençal costume worn by the sitter as evidence for a different reading of the painting's aesthetic sources. But my own search for Provençal origins for this *particular* costume did not produce a match. Should we be surprised by this? Surely not. Again, Cézanne, like Corot, avoided particularity. Yet there *is* another avenue of Provençal identity that should be explored before discounting this pursuit altogether.

André Gouirand, the Provençal art historian and friend of Cézanne's friend Joachim Gasquet, published the first modern study of the French region's painting in 1901. This book, while ignoring Cézanne, articulated a history of "true" Provençal painting that had its roots in the eighteenth-century artist Françoise Duparc. Gouirand thought Duparc was born in Provence, although we now know that she was born in Spain to a Provençal father and a Spanish mother. When Duparc died in Marseille in 1778, she bequeathed four paintings to the city, all of which are now in the Musée des Beaux Arts there. One of them, *The Knitter* (*La tricoteuse*, ca. 1750–78, ill. 56), was reproduced in Gouirand's book, and Cézanne might well have known her art even before 1901, given that he went often to Marseille. This might seem recondite and perhaps irrelevant in an essay on a late Cézanne figure painting, but I want at least to consider the idea that the Getty Cézanne ties in to what we might call his non-Parisian, or even anti-Parisian, aesthetic. When we consider Duparc's *The Knitter* in connection with a famous late Cézanne figure picture that is often compared to the Getty painting, *The Old Woman with a Rosary* (ca. 1895–96, ill. 57) in the National Gallery in London, a whole new aesthetic avenue opens up.

All the lore around the London Cézanne involves Provence. We learn from the usually unreliable Gasquet that, late in his career, Cézanne took in an elderly nun who had lost her faith and provided her employment and protection. Gasquet identifies her as the model for the London picture, although he never quite explains why she is represented praying with a large rosary if she has lost her faith! Be that as it may, the Cézanne could easily have been a pictorial response to Duparc's figure painting in which

56 Françoise Duparc, *The Knitter,* ca. 1750–78

57 Paul Cézanne, *The Old Woman with a Rosary,* ca. 1895–96

the young knitter of the eighteenth century became an ancient woman by 1900, whose activity is as repetitive, as instinctive, as knitting. The pose and viewpoint are virtually identical, and the darkness of the Cézanne a reversal of the lightness of the Duparc.

 The idea that there was a viable tradition of painting in Provence and that Cézanne was the culmination of it is compelling when we think about his own conflicted professional and personal life—namely, a completely Provençal family and upbringing in contrast to a Parisian (or, at the very least, Paris-based) wife and son, with a consequent life of shuttling back and forth. The nationalist and international aesthetic ambitions of the Louvre and the Paris-centered French art world had an earthy counter in the landscape, peoples, and traditions of Provence. It is in Provence that Cézanne's "classicism," particularly his close readings of Greek and Latin texts in the original languages and in translation, was centered. The idea of Provence as a "classical" rather than a French place, linked with all aspects of the Mediterranean world and its venerated antiquity, was part of Cézanne's own cultural lore. If he did know about Françoise Duparc, he would have thought that she was born, like him, in Provence and that she died there after having spent significant periods of her professional life

in Paris and London. The four studio paintings by her in Marseille's Musée des Beaux-Arts all represent ordinary people, presumably of Marseille, in simple and clear pictorial modes. Excluding the knitter, the other three look directly at us as if they are the subjects of portraits, yet in no case do we read the pictures as portraits. They represent people who could never have afforded to commission their likenesses from a professional painter, and must have been selected as models by the painter herself.

The facts that Duparc's father was a Marseille-born sculptor, that she trained as a painter in Marseille before embarking on her non-Provençal career, that she ended her life in the place of her aesthetic birth, and that she left to the city four of her paintings of its citizens would have appealed to Cézanne, and I would argue that his late figure paintings of ordinary Provençal people are rooted, at least in part, in Duparc's aesthetic of the ordinary. What she did, to represent ordinary people, is precisely what Cézanne would later do in his Provençal figure paintings of card players, workers, gardeners, and venerable old people.

Let's return to the Getty Cézanne, and to this model represented in a darkened interior free of props except for the floral fabric arranged in heavy folds on the table. When we consider the Parisian and the Provençal that Cézanne evokes here, as articulated in the preceding paragraphs, the Getty Cézanne seems to trend more to the Parisian side of the artist's dualism, but, as is usual with this elusive painter, we cannot pin it down. The fabric might well have gone back and forth between Paris and Aix-en-Provence, because we see it in still-life paintings that have no clear geographical location, and the costume worn by the woman could well have consisted of Provençal elements even if the painting was made in Paris. Even the "Italian" origin usually attributed to the model could have equal relevance to Cézanne's Parisian and Provençal identities. What we have here is a kind of beauty that is at once elemental and profoundly European, and that presupposes a culture that survives all forms of modernity. Although the rail travel of the industrial age made Cézanne's conflicted Paris-Provence duality possible, it plays almost no role in his pictorial world, particularly in the late paintings. In fact, only the industrial landscape out the window of his Parisian studio in his 1899 *Portrait of Ambroise Vollard* (ill. 58) and the classical-looking railroad bridge that enlivens the middle ground of the late Mont Sainte-Victoire views remind us of his train-based back-and-forth life.

Like Françoise Duparc, Cézanne returned to Provence to die, leaving Paris to his wife, his son, and his dealers, and creating conditions that

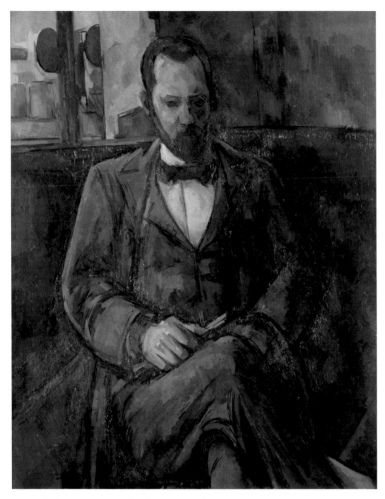

58 Paul Cézanne, *Portrait of Ambroise Vollard*, 1899

forced young acolytes like Émile Bernard to come to him in the South.
Like many people, he returned to the religion of his youth as an elderly
traditionalist, and we know that his values trended toward the conserva-
tive. So too the paintings, which evoke a world that is all but timeless, if
we think only about European time. Yet that world was not without its
tensions, and these are expressed in pictorial ways so strongly that they
forced generations of twentieth-century art historians to see Cézanne as
thoroughly modern. The Cézanne of Meyer Schapiro was the twentieth-
century Cézanne, not the old traditionalist who tried to locate an enduring

type of beauty in what the French call *la longue durée*. The Cézanne who visited the Louvre obsessively would no doubt be stunned to discover his paintings not as the culmination of European and Provençal painting in the Louvre or the Musée Granet in Aix-en-Provence but in the Museum of Modern Art in New York. There, they are presented as the beginning of an industrial, modern art that stressed flatness, geometry, and a new order very different from that of Cézanne's own world, which was firmly rooted in Europe, from Greek times to his present.

The pictorial tensions of surface-space, warm-cool hues, and curvilinear-rectilinear lines so powerfully evoked by Schapiro are certainly present in the Getty Cézanne. But the modernity they imply is one of form, not content, and is thus the opposite of Manet's modernity. When we compare the head and hands of Manet's *Jeanne* and of Cézanne's "Italian" model, the contrast is startling. Cézanne's representation of the model's left hand is so basic and so unforgivingly structural that one cannot imagine holding it in one's own. And her head is an egg-like oval of such weight that it needs all the structural support of the right forearm, which looks more like a piece of wood than a flesh-covered, bracelet-laden female arm. The head too is a basic form, and Cézanne could not be bothered with the details of the eyebrows, the blush of the cheek, plump lips, or a stunning profile. We can hardly imagine the Italian model's thoughts, as her eyes seem sightless and inexpressive. When we look at her, we think of Constantin Brancusi's oval heads, not of Baroque painting or Impressionism. Here, the beauty is not of the woman herself, as it was with Manet, who embraced the perfection of youth in Jeanne de Marsy. Cézanne wants us to accept this woman as a model, simple as that, not as a particular woman of a particular age at a particular time. For him, beauty was the opposite of particular. The "here and now" interested him little.

Cézanne's kind of timeless modernity has enjoyed a long afterlife because of its very aesthetic durability. Indeed, the immemorial modernity of Gauguin and the timeless modernity of Cézanne appealed more to subsequent modernists than the "of its time and place" modernity of the Baudelairean Manet. The "classical" figure paintings of Pablo Picasso, the nudes of Fernand Léger and Amedeo Modigliani, the dancers of Henri Matisse, and their abstract variants in Jackson Pollock, Clyfford Still, and Mark Rothko—all of their roots can be traced to Gauguin's chromatic experiments and Cézanne's "back to basics" ideas of composition and imagery.

59 Paul Cézanne, *Fruit Bowl, Glass, and Apples* (*Still Life with Fruit Dish*), ca. 1879–80

60 Paul Gauguin, *Woman in Front of a Still Life by Cézanne*, 1890

61 Maurice Denis, *Homage to Cézanne*, 1900

Consider this description by an artist, written in 1902, of a still life by Cézanne to understand how truly elemental his painting is:

> Ripe grapes run off the edges of a bowl—Green and dark red apples mingle on the [surrounding] cloth—The whites appear to be blue and the blues come off as white—What a noble painter, that Cézanne.

The writer, Paul Gauguin, was referring to a Cézanne still life he once owned (ill. 59), purchased in the late 1870s directly from the artist. Before he sold it, he included it in the background of one of his own paintings (ill. 60). In 1900, the same Cézanne still life became internationally known when it was the subject of a mural-size painting by Maurice Denis (ill. 61). It was the only still life in Gauguin's small collection, and Denis's immortalization of it at the beginning of the new century is likely what prompted Gauguin's memory in 1902. He needed only a few words to characterize its enduring beauty.

AFTER-
THOUGHTS

For me, the author, these lecture-essays require no summarizing conclusion because my entire argument is that there is no one modern beauty. Rather, each artist and his or her critics and commentators must search for a beauty particular to each work of art. Each of the three artists I have focused on strived for a beauty that was ultimately unattainable, necessitating the creation of more works of art. And each viewer walking through a gallery discovers in a work a beauty particular not only to it, but to him/herself.

As I was writing this essay, I read a review of an exhibition of works from the collection of the editor-collector Scofield Thayer that hit me like a bolt of lightning. In one sentence, the author said precisely what I had labored over three lectures to express:

> Beauty is not in the eye of the beholder, neither is it in the work of art—these are but the flint and the tinder, which, being brought together, give the spark called beauty.

Yet I wish to extend the metaphor. Beauty is not just a spark. It can actually light a fire that burns for a much longer time in the mind of the viewer.

In my lectures and these essays, I found myself returning again and again to the idea of "resonance," borrowing a sonic simile for a visual interpretive context. At various points in each of the essays, works of art by other artists, many completely unknown to the artist under discussion, helped me better understand the work at hand. This flies in the face of everything I was taught when I studied art history nearly fifty years ago at Yale University. In the tightly ordered academic context, the word "influence," which had been so important in my youth when I went to the local museum and talked with my friends and family, was repudiated for its vagueness. Instead, we learned to focus on "sources," and to be precise in our application of that term. In connecting a particular work to another, earlier work, we had to demonstrate clearly that the artist actually saw the earlier work either in the original or in reproduction, and only then could the discussion have historical

validity. Yet through the years, the limits of this method have become ever clearer to me. I now frequently make comparisons that fall outside the rigorous limits of source analysis when lecturing to undergraduates or walking with a companion or a tour group through a museum.

For years, I felt guilty about this sloppier kind of comparison—of a Manet to a Rembrandt he never saw, of a Gauguin to an anonymous Venetian painting in an American museum, of a Cézanne to a Corot probably unknown to him. But the more I thought about the way my visual memory works (imperfectly, like most anyone's), the more obvious it became that, particularly in our age of image glut, there are innumerable links among works of art and artists that are no less valid for their undocumented-ness. Indeed, these undocumented links are so numerous that they engulf the "sources" so fetishized by art historians.

I *constantly* perceive powerful, aesthetically meaningful links between works of art that are completely unrelated historically, and pursuing those comparisons makes the works richer in my eyes. Perhaps the resonance I speak of can be considered a common language among many painters, having to do with an artist's intuitive understanding of beauty that documentary evidence and intellectual investigations cannot fully corroborate. I am absolutely certain that, were Gauguin to walk today through the galleries of the Cleveland Museum of Art, he would rush to the painted head of John the Baptist, thinking all the while of his *Arii matamoe*. Did he know the head in Amiens? Most likely not. Do we care? Yes and no.

Indeed, it is not *Gauguin* who needed to have seen those two heads; it is us, the commentators, who struggle to articulate what seems at first a ghoulish beauty in his painting. In thinking about beauty, we must realize that it involves us as well as the artist, and that, like that artist, we bring to bear in every situation our particular knowledge, visual repertoire, and emotional state. This means we inevitably arrive at a kind of compromised beauty that will be altered or even erased by the next viewer. That there is no consensus on beauty is fundamental to it as a concept.

That there are "better" viewers goes without saying. People who spend their lives looking at, remembering, forgetting, and reflecting upon works of art produce more persuasive analysis than people who lack the deep training common to curators, art historians, and artists. But training has its limits. The unprepared viewer can often have startlingly clear, less compromised reactions to a work of art than a professional viewer like myself. One of the joys of teaching is that we constantly learn from our students. We also must

remember that artists and art historians have different ways of seeing, of remembering, and of interpreting. Most artists care less about the interpreting part, and even if they do care (as in the case of Gauguin or Vincent van Gogh), they do so at their own risk, because no one artist and no one viewer can ever get it "right."

So, I am all for the creative deployment of "resonance" among works of art, and for a dramatic loosening of constraints when comparing works. We organize works of art in museums and books so that they are with similar works of art. Too rarely do we run from one gallery to another, distant one to make a new comparison. At this stage of my career, I am confident in my assertion that the better an artwork is, the less it benefits from categorization. Let us liberate ourselves as viewers, as searchers for beauty, and travel far and wide on our aesthetic journeys, allowing ourselves and the works we love a freedom of resonance, and a spark that can become a fire.

LIST
OF
ILLUSTRATIONS

INTRODUCTION
MODERN BEAUTY

1

Eugène Delacroix (French, 1789–1863), *The Death of Sardanapalus*, 1827. Oil on canvas, 392 × 496 cm (154⅜ × 195¼ in.). Paris, Musée du Louvre, RF 2346. © Musée du Louvre, Dist. RMN-Grand Palais / Angèle Dequier / Art Resource, NY. Photo: Angèle Dequier

2

Jean-Auguste-Dominique Ingres (French, 1780–1867), *The Apotheosis of Homer*, 1827. Oil on canvas, 386 × 512 cm (152 × 201⅝ in.). Paris, Musée du Louvre, INV.5417. © RMN-Grand Palais / Art Resource, NY. Photo: René-Gabriel Ojéda

IS BEAUTY TRANSITORY?
ÉDOUARD MANET'S *JEANNE*

3

Édouard Manet (French, 1832–1883), *Jeanne* (*Spring*), 1881. Oil on canvas, 74 × 51.5 cm (29⅛ × 20¼ in.). Los Angeles, J. Paul Getty Museum, 2014.62

4

Édouard Manet (French, 1832–1883), *At the Restaurant of Mr. Lathuille* (*Chez le père Lathuille*), 1879. Oil on canvas, 92 × 112 cm (36¼ × 44 in.). Tournai, Belgium, Musée des Beaux-Arts. Photo: Scala / Art Resource, NY

5

Édouard Manet (French, 1832–1883), *Antonin Proust*, 1880. Oil on canvas, 129.5 × 95.9 cm (51 × 37¾ in.). Toledo, OH, Toledo Museum of Art, Gift of Edward Drummond Libbey, 1925.108.

6

Édouard Manet (French, 1832–1883), *Portrait of Mr. Eugène Pertuiset, Lion Hunter* (*Portrait de M. Eugène Pertuiset, le chasseur de lions*), 1881. Oil on canvas, 150.5 × 171.5 cm (59¼ × 67⅜ in.). Museu de Arte de São Paulo Assis Chateaubriand, Gift of Gastão Vidigal and Geremia Lunardelli, 1950, MASP.00079. Photo: João Musa

7

Édouard Manet (French, 1832–1883), *Portrait of Henri Rochefort*, 1881. Oil on canvas, 81.5 × 66.5 cm (32⅛ × 26⅛ in.). Hamburg, Germany, Hamburger Kunsthalle. Photo: bpk Bildagentur / Hamburger Kunsthalle, Hamburg, Germany / Elke Walford / Art Resource, NY. Photo: Elke Walford

8

Édouard Manet (French, 1832–1883), *A Bar at the Folies-Bergère* (*Un bar aux Folies-Bergère*), 1882. Oil on canvas, 96 × 130 cm (37¹³⁄₁₆ × 51³⁄₁₆ in.). London, The Samuel Courtauld Trust, The Courtauld Gallery, P.1934.SC.234. Photo: The Samuel Courtauld Trust, The Courtauld Gallery, London

9
Édouard Manet (French, 1832–1883), *Jeanne* (*Spring*), 1881. Oil on canvas, 74 × 51.5 cm (29⅛ × 20¼ in.). Los Angeles, J. Paul Getty Museum, 2014.62

10
Édouard Manet (French, 1832–1883), *Portrait of Isabelle Lemonnier with a Muff*, ca. 1879. Oil on canvas, 93 × 73.7 cm (36⅝ × 29 in.). Dallas Museum of Art, gift of Mr. and Mrs. Algur H. Meadows and the Meadows Foundation, Incorporated, 1978.1. Photo: Dallas Museum of Art, Texas, USA. Gift of Mr. and Mrs. Algur H. Meadows and the Meadows Foundation, Incorporated / Bridgeman Images

11
Édouard Manet (French, 1832–1883), *Study of Méry Laurent* (*Autumn*), 1882. Oil on canvas, 73 × 51 cm (28¾ × 20 in.). Nancy, France, Musée des Beaux-Arts de Nancy. Photo: Nancy, Musée des Beaux-Arts, cliché P. Mignot

12
Pierre-Auguste Renoir (French, 1841–1919), *Portrait of Miss de Marsy* (*Woman Leaning*), 1882. Oil on canvas, 61 × 50.5 cm (24 × 19⅞ in.). Private collection. Photo: Historic Collection / Alamy Stock Photo

13
Pierre-Auguste Renoir (French, 1841–1919), *On the Terrace* (*Two Sisters*), 1881. Oil on canvas, 100.4 × 80.9 cm (39½ × 31⅞ in.). Art Institute of Chicago, Mr. and Mrs. Lewis Larned Coburn Memorial Collection, 1933.455. Photo: The Art Institute of Chicago / Art Resource, NY

14
Pierre-Auguste Renoir (French, 1841–1919), *La Parisienne*, 1874. Oil on canvas, 163.2 × 108.3 cm (64¼ × 42⅝ in.). Cardiff, National Museum Wales, Bequest of Gwendoline Davies, NMW A 2495. Photo: National Museum Wales / HIP / Art Resource, NY

15
Édouard Manet (French, 1832–1883), *The Amazon*, ca. 1882. Oil on canvas, 73 × 52 cm (28¾ × 20½ in.). Madrid, Museo Nacional Thyssen-Bornemisza, 659 (1980.5). Photo: Scala / Art Resource, NY

16
Berthe Morisot (French, 1841–1895), *Winter* (*Woman with a Muff*), 1880. Oil on canvas, 74.9 × 61.6 cm (29½ × 24¼ in.). Dallas Museum of Art, gift of the Meadows Foundation, Incorporated, 1981.129. Photo: Dallas Museum of Art, Texas, USA. Gift of the Meadows Foundation, Incorporated / Bridgeman Images

17
James Tissot (French, 1836–1902), *October*, 1877. Oil on canvas, 216.5 × 108.7 cm (85¼ × 42¾ in.). Quebec, Musée des Beaux-Arts de Montréal, Gift of Lord Strathcona and family, 1927.410. Photo: Courtesy of Wikimedia Commons CC-BY-SA 4.0

18
Pisanello (Antonio di Puccio Pisano; Italian, 1395–1455), *Portrait of an Este Princess*, ca. 1432–36. Oil on poplar wood, 43 × 30 cm (17 × 11⅞ in.). Paris, Musée du Louvre, RF 766. © RMN-Grand Palais / Art Resource, NY. Photo: Franck Raux

19
Rembrandt van Rijn (Dutch, 1606–1669), *Flora*, ca. 1654–60. Oil on canvas, 100 × 91.8 cm (39⅜ × 36⅛ in.). New York, Metropolitan Museum of Art, Gift of Archer M. Huntington, in memory of his father, Collis Potter Huntington, 1926, 26.101.10. Photo: www.metmuseum.org, CC0

20
Nicolas Poussin (French, 1594–1665), *Spring*, ca. 1660–64. Oil on canvas, 118 × 160 cm (46½ × 63 in.). Paris, Musée du Louvre, INV 7303. © RMN-Grand Palais / Art Resource, NY. Photo: Stéphane Maréchalle

21
Édouard Manet (French, 1832–1883), *Nina de Callias*, 1873. Oil on canvas, 113.5 × 166.5 cm (44⅝ × 65½ in.). Paris, Musée d'Orsay, RF 2850. © RMN-Grand Palais / Art Resource, NY. Photo: Hervé Lewandowski

22
Front cover of Ernest Hoschedé, *Impressions of My Trip to the Salon of 1882* (Paris: Typographie Tolmer et Cie., 1882), featuring reverse color reproduction of Manet's *Jeanne*. Paris, Bibliothèque Nationale de France. Photo: Bibliothèque Nationale de France, Paris

23
Black-and-white reproduction of Manet's drawing of *Jeanne*, after his painting, in Antonin Proust, "Le Salon de 1882," *Gazette des Beaux-Arts*, June 1, 1882, 545. Paris, Bibliothèque Nationale de France. Photo: Bibliothèque Nationale de France, Paris

IS BEAUTY IMMEMORIAL?
PAUL GAUGUIN'S *ARII MATAMOE*

24
Paul Gauguin (French, 1848–1903), *Arii matamoe* (*La fin royale*), 1892. Oil on coarse fabric, 45.1 × 74.3 cm (17¾ × 29¼ in.). Los Angeles, J. Paul Getty Museum, 2008.5

25
Paul Gauguin (French, 1848–1903), *Two Tahitian Women and a Marquesan Earplug*, ca. 1891–93. Ink and graphite on parchment, 24 × 31.8 cm (9½ × 12½ in.). Art Institute of Chicago, David Adler Collection, 1950.1413. Photo: The Art Institute of Chicago / Art Resource, NY

26
Polynesian, *pu'taiana* (ear ornaments), nineteenth century. Whale ivory, each 1.6 × 4.1 × 0.6 cm (⅝ × 1⅝ × ¼ in.). New Bedford Whaling Museum, Massachusetts, 2001.100.2344. Photo: Courtesy of the New Bedford Whaling Museum

27
Patoromu Tamatea (New Zealand, Ngati Tamateatutahi, subtribe of Ngati Pikiao, d. ca. 1890), *Round Bowl with Lid with Two Figure Supports, Kumete*, ca. 1850–1900. Wood and paua shell, 56 × 61 × 38 cm (22 × 24 × 15 in.). Auckland War Memorial Museum, New Zealand, no. 117. Photo: Kumete, Patoromu Tamatea. Ngā Iwi o Te Arawa. Auckland War Memorial Museum Tāmaki Paenga Hira. AM117

28
Photographs of a Peruvian mummy, twelfth–fifteenth century, exhibited at the Musée de l'ethnographie du Trocadéro, Paris, in 1878 and reproduced in Ernest-Théodore Hamy, *Galerie américaine du musée d'ethnographie du Trocadéro* (Paris: E. Leroux, 1897), plate 33, following its description on pp. 65–66. At the 1878 Exposition Universelle, Paris, three Peruvian mummies were exhibited in the anthropology section. This mummy is now housed at the Musée de l'Homme in the Palais Chaillot, built on the same site as the Trocadéro after it was demolished in 1935, for which, see Brettell, Frèches-Thory, et al., *The Art of Paul Gauguin*, 147. Photo: Bibliothèque Nationale de France, Paris

29
Paul Gauguin (French, 1848–1903), *Ondine* (*In the Waves*), 1889. Oil on fabric, 92.5 × 72.4 cm (36⅜ × 28½ in.). Cleveland Museum of Art, Gift of Mr. and Mrs. William Powell Jones, 1978.63. Photo: Cleveland Museum of Art, OH, USA. Gift of Mr. and Mrs. William Powell Jones / Bridgeman Images

30
Paul Gauguin (French, 1848–1903), *The Call*, 1902. Oil on fabric, 131.3 × 89.5 cm (51¹¹⁄₁₆ × 35³⁄₁₆ in.). Cleveland Museum of Art, Gift of the Hanna Fund, 1943.392. Photo: Cleveland Museum of Art, OH, USA. Gift of the Hanna Fund / Bridgeman Images

31
Paul Gauguin (French, 1848–1903), *Where Do We Come From? What Are We? Where Are We Going?* (*D'où venons nous? Que sommes nous? Où allons nous?*), 1897–98. Oil on canvas, 139.1 × 374.6 cm (54¾ × 147½ in.). Museum of Fine Arts, Boston, Tompkins Collection—Arthur Gordon Tompkins Fund, 36.270. Photograph © 2019 Museum of Fine Arts, Boston

32
Detail of ill. 31

33
Major-General Horatio Gordon Robley, drawing of a female Maori head with postmortem tattooing, probably done for purposes of selling the head. Published in Robley's *Maori Tattooing* (1896), 200

34
Peruvian, Moche portrait vessel of a ruler, ca. 100 BCE–500 CE. Ceramic and pigment, 28.6 × 16.5 × 21.6 cm (11¼ × 6½ × 8½ in.). Art Institute of Chicago, Kate S. Buckingham Endowment, 1955.2339. Photo: The Art Institute of Chicago / Art Resource, NY

35
Paul Gauguin (French, 1848–1903), *Self-Portrait as Severed Head*, 1889. Stoneware, glaze and gilding, H: 19.5 cm (7⅝ in.). Copenhagen, Designmuseum Danmark. Photo: Designmuseum Danmark / Pernille Klemp

36
Paul Gauguin (French, 1848–1903), *The Two Pots* (*Wood Tankard and Metal Pitcher*), 1880. Oil on linen canvas, 54 × 65 cm (21¼ × 25⅝ in.). Art Institute of Chicago, A Millennium Gift of Sara Lee Corporation, 1999.362. Photo: The Art Institute of Chicago / Art Resource, NY

37
Paul Gauguin (French, 1848–1903), *Still Life in an Interior*, 1885. Oil on canvas, 60 × 74 cm (23⅝ × 29⅑ in.). Switzerland, private collection. Photo: Pictures Now / Alamy Stock Photo

38
Paul Cézanne (French, 1839–1906), *The Three Skulls*, ca. 1900. Oil on canvas, 34.9 × 61 cm (13¾ × 24 in.). Detroit Institute of Arts, Bequest of Robert H. Tannahill, 70.163. Photo: Detroit Institute of Arts, USA. Bequest of Robert H. Tannahill / Bridgeman Images

39
Paul Cézanne (French, 1839–1906), *Still Life with Skull, Candle, and Book*, 1866. Oil on canvas. Private collection. Photo: Erich Lessing / Art Resource, NY

40
Unknown artist (Spain or northern Italy), *Head of Saint John the Baptist*, ca. 1550–1650. Oil on canvas, 50 × 75.2 cm (19⅝ × 29⁹⁄₁₆ in.). Cleveland Museum of Art, Mr. and Mrs. William H. Marlatt Fund, 1953.424. Photo: Cleveland Museum of Art, OH, USA. Mr. and Mrs. William H. Marlatt Fund / Bridgeman Images

41
Gustave Moreau (French, 1826–1898), *The Apparition*, ca. 1876–77. Oil on canvas, 55.9 × 46.7 cm (22 × 18⅜ in.). Cambridge, Massachusetts, Harvard Art Museums/Fogg Museum, Bequest of Grenville L. Winthrop, 1943.268. Photo: Imaging Department © President and Fellows of Harvard College

42
Photograph of King Pomare V, reproduced in Henri Le Chartier, *Tahiti et les colonies françaises de la Polynésie* (Paris: Jouvet et Cie., 1887), 33. This photo was also pasted by Gauguin on page 37 of his manuscript of *Noanoa* (1893–94), for which see Gauguin, *Noanoa: Voyage à Tahiti*, facsimile ed. (1947).

IS BEAUTY BEYOND TIME?
PAUL CÉZANNE'S
YOUNG ITALIAN WOMAN AT A TABLE

43
Paul Cézanne (French, 1839–1906), *Young Italian Woman at a Table*, ca. 1895–1900. Oil on canvas, 92.1 × 73.5 cm (36¼ × 28¹⁵⁄₁₆ in.). Los Angeles, J. Paul Getty Museum, 99.PA.40

44
Paul Cézanne (French, 1839–1906), *Boy in the Red Vest*, ca. 1889–90. Oil on canvas, 79.5 × 64 cm (31¼ × 25⅛ in.). Zürich, Foundation E. G. Bührle. Photo: Erich Lessing / Art Resource, NY

45
Paul Cézanne (French, 1839–1906), *Woman with a Coffee Pot*, ca. 1890–95. Oil on canvas, 130 × 97 cm (51⅛ × 38⅛ in.). Paris, Musée d'Orsay, RF 1956 13. © RMN-Grand Palais / Art Resource, NY. Photo: Hervé Lewandowski

46
Albrecht Dürer (German, 1471–1528), *Melancolia I*, 1514. Engraving, 24 × 18.5 cm (9⁷⁄₁₆ × 7⁵⁄₁₆ in.). New York, Metropolitan Museum of Art, Harris Brisbane Dick Fund, 1943, 43.106.1. Image copyright: © The Metropolitan Museum of Art. Image source: Art Resource, NY

47
Lucas Cranach the Elder (German, 1472–1553), *Melancholy*, 1532. Oil on panel, 51 × 97 cm (20 × 38⅛ in.). Copenhagen, Statens Museum for Kunst, KMSsp722. Photo: Statens Museum for Kunst, Copenhagen / HIP / Art Resource, NY

48
Edvard Munch (Norwegian, 1863–1944), *Melancholy*, 1894–96. Oil on canvas, 81 × 100.5 cm (31⅞ × 39⁹⁄₁₆ in.). Bergen Kunstmuseum. © 2019 Artists Rights Society (ARS), New York. Photo: Erich Lessing / Art Resource, NY

49
Hendrick ter Brugghen (Dutch, 1588–1629), *Melancolia*, ca. 1627. Oil on canvas, 67 × 46.5 cm (26⅜ × 18⅜ in.). Toronto, Art Gallery of Ontario, on loan from Kunstsammlungen Graf von Schönborn, AGOID.18793

50

Paul Cézanne (French, 1839–1906), *Young Man and Skull*, (*Jeune homme à la tête de mort*), ca. 1896–98. Oil on canvas, 130 × 97.5 cm (51³⁄₁₆ × 38³⁄₈ in.). Philadelphia, Barnes Foundation, BF929. Image © 2018 The Barnes Foundation

51

Rembrandt van Rijn (Dutch, 1606–1669), *Bathsheba at Her Bath*, 1654. Oil on canvas, 142 × 142 cm (55⁷⁄₈ × 55⁷⁄₈ in.). Paris, Musée du Louvre, M.I. 957. © RMN-Grand Palais / Art Resource, NY. Photo: Mathieu Rabeau

52

Rembrandt van Rijn (Dutch, 1606–1669), *Self-Portrait at the Easel*, 1660. Oil on canvas, 111 × 85 cm (43³⁄₄ × 33¹⁄₂ in.). Paris, Musée du Louvre, INV 1747. © RMN-Grand Palais / Art Resource, NY. Photo: Tony Querrec

53

Raphael (Italian, 1483–1520), *Balthazar Castiglione*, ca. 1514–15. Oil on canvas, 82 × 67 cm (32¹⁄₄ × 26³⁄₈ in.). Paris, Musée du Louvre, INV 611. © RMN-Grand Palais / Art Resource, NY. Photo: Tony Querrec

54

Jean-Baptiste-Camille Corot (French, 1796–1875), *Reverie*, ca. 1860–65. Oil on wood, 49.8 × 36.5 cm (19⁵⁄₈ × 14³⁄₈ in.). New York, Metropolitan Museum of Art, H. O. Havemeyer Collection, Bequest of Mrs. H. O. Havemeyer, 1929, 29.100.563. Photo: www.metmuseum.org, CC0

55

Jean-Baptiste-Camille Corot (French, 1796–1875), *Interrupted Reading* (*Lecture interrompue*), ca. 1870. Oil on canvas mounted on board, 92.5 × 65.1 cm (36³⁄₈ × 25⁵⁄₈ in.). Art Institute of Chicago, Potter Palmer Collection, 1922.410. Photo: The Art Institute of Chicago / Art Resource, NY

56

Françoise Duparc (French, 1705–1778), *The Knitter* (*La tricoteuse*), ca. 1750–78. Oil on canvas, 78 × 64 cm (30³⁄₄ × 25¹⁄₈ in.). Marseille, Musée des Beaux-Arts, bequeathed in 1778, no. 406. © RMN-Grand Palais / Art Resource, NY. Photo: Jean Bernard

57

Paul Cézanne (French, 1839–1906), *The Old Woman with a Rosary*, ca. 1895–96. Oil on canvas, 80.6 × 65.5 cm (31³⁄₄ × 25³⁄₄ in.). London, National Gallery, NG6195. Photo: © National Gallery, London / Art Resource, NY

58

Paul Cézanne (French, 1839–1906), *Portrait of Ambroise Vollard*, 1899. Oil on canvas, 101 × 81 cm (39³⁄₄ × 31⁷⁄₈ in.). Musée de la Ville de Paris, Musée du Petit-Palais, PPP2100. © RMN-Grand Palais / Art Resource, NY. Photo: Bulloz

59

Paul Cézanne (French, 1839–1906), *Fruit Bowl, Glass, and Apples* (*Still Life with Fruit Dish*), ca. 1879–80. Oil on canvas, 46.4 × 54.6 cm (18¹⁄₄ × 21¹⁄₂ in.). New York, Museum of Modern Art, Gift of Mr. and Mrs. David Rockefeller, 69.1991. Digital Image © The Museum of Modern Art / Licensed by SCALA / Art Resource, NY

60

Paul Gauguin (French, 1848–1903), *Woman in Front of a Still Life by Cézanne*, 1890. Oil on linen canvas, 65.3 × 54.9 cm (25³⁄₄ × 21⁵⁄₈ in.). Art Institute of Chicago, Joseph Winterbotham Collection, 1925.753. Photo: The Art Institute of Chicago / Art Resource, NY

61

Maurice Denis (French, 1870–1943), *Homage to Cézanne*, 1900. Oil on canvas, 182 × 243.5 cm (71⁵⁄₈ × 95⁷⁄₈ in.). Paris, Musée d'Orsay, RF 1977 137, LUX 48. © RMN-Grand Palais / Art Resource, NY. Photo: Adrien Didierjean. © 2019 Artists Rights Society (ARS), New York

SUGGESTED
FURTHER
READING

Baudelaire, Charles. *The Painter of Modern Life*. Translated by P. E. Charvet. London and New York: Penguin, 2010.

Benjamin, Walter. "The Work of Art in the Age of Mechanical Reproduction." In *Art in Theory, 1900–1990: An Anthology of Changing Ideas*, edited by Charles Harrison and Paul Wood, 512–20. Oxford: Blackwell Publishers Ltd., 1992.

Berson, Ruth. *The New Painting: Impressionism 1874–1886*. Vol. 1, *Reviews*. San Francisco: Fine Arts Museums of San Francisco, 1996.

———. *The New Painting: Impressionism 1874–1886*. Vol. 2, *Exhibited Works*. San Francisco: Fine Arts Museums of San Francisco, 1996.

Brettell, Richard R. *Modern Art 1851–1929: Capitalism and Representation*. Oxford: Oxford University Press, 1999.

Clark, T. J. *Farewell to an Idea: Episodes from a History of Modernism*. New Haven, CT: Yale University Press, 2001.

———. *The Painting of Modern Life: Paris in the Art of Manet and His Followers*. New York: Random House, 1984.

Distel, Anne. *Les collectionneurs des impressionnistes: Amateurs et marchands*. Düdingen/Guin, Switzerland: Éditions Trio et la Bibliothèque des Arts, 1989.

Dolent, Jean. *Amoureux d'art*. Paris: Alphonse Lemerre, Éditeur, 1888.

———. *Monstres*. Paris: Alphonse Lemerre, Éditeur, 1896.

———. *Petit manuel d'art à l'usage des ignorants*. Paris: Alphonse Lemerre, Éditeur, 1874.

Eisenman, Stephen, et al. *Nineteenth-Century Art: A Critical History*. London: Thames and Hudson, 1994.

Herbert, Robert L. *Impressionism: Art, Leisure, and Parisian Society*. New Haven, CT: Yale University Press, 1988.

Huysmans, Joris-Karl. *L'art moderne*. Paris: G. Charpentier, 1883.

Moffett, Charles S., ed. *The New Painting: Impressionism 1874–1886*. Exhibition catalogue. San Francisco: Fine Arts Museums of San Francisco, 1986.

Rabinow, Rebecca A. *Cézanne to Picasso: Ambroise Vollard, Patron of the Avant-Garde*. With essays by Ann Dumas, Robert Jensen, Douglas W. Druick, et al. Exhibition catalogue. New York: Metropolitan Museum of Art, 2006.

Rewald, John. *Studies in Impressionism*. Edited by Irene Gordon and Frances Weitzenhoffer. New York: Harry N. Abrams, 1985.

———. *Studies in Post-Impressionism*. Edited by Irene Gordon and Frances Weitzenhoffer. New York: Harry N. Abrams, 1986.

Signac, Paul. *D'Eugène Delacroix au néo-impressionnisme*. 4th ed. Paris: Librairie Floury, 1939.

MANET

Allan, Scott, Emily A. Beeny, and Gloria Groom, eds. *Manet and Modern Beauty: The Artist's Last Years*. Exhibition catalogue. Los Angeles: J. Paul Getty Museum and the Art Institute of Chicago, 2019.

Bailey, Colin B., et al. *Renoir Portraits: Impressions of an Age*. Exhibition catalogue. New Haven, CT: Yale University Press, 1998.

Bataille, Georges, and Françoise Cachin. *Manet*. Geneva: Skira, 1983.

Brettell, Richard R., Françoise Cachin, and Sylvain Amic. *L'impressionnisme, de France et d'Amérique: Monet, Renoir, Sisley, Degas*. Versailles: Artlys, 2007.

Burnham, Helen. "Fashion and the Representation of Modernity: Studies in the Late Work of Édouard Manet (1832–1883)." PhD diss., New York University, 2007.

Cachin, Françoise. *Manet*. London: Barrie and Jenkins, 1990.

———. *Manet: J'ai fait ce que j'ai vu*. Paris: Gallimard, 2011.

Cachin, Françoise, and Stéphane Guégan. *Manet: The Man Who Invented Modernity*. Exhibition catalogue. Paris: Gallimard, 2011.

Cachin, Françoise, and Rachel Kaplan. *Manet, Painter of Modern Life*. London: Thames and Hudson, 1995.

Cachin, Françoise, Charles S. Moffett, and Juliet Wilson-Bareau. *Manet, 1832–1883*. Exhibition catalogue. Paris: Ministère de la culture, Éditions de la réunion des musées nationaux, 1983.

Groom, Gloria, and Geneviève Westerby, eds. *Manet Paintings and Works on Paper at the Art Institute of Chicago*. 2017. An online scholarly catalogue initiative. https://publications.artic.edu/manet/reader/manetart /section/140020.

Groom, Gloria Lynn. *Impressionism, Fashion, and Modernity*. Exhibition catalogue. Chicago: Art Institute of Chicago, 2012.

Guégan, Stéphane. *Manet, inventeur du moderne*. Exhibition catalogue. Paris: Gallimard, 2011.

Hoschedé, Ernest. *Impressions de mon voyage au Salon de 1882*. Paris: Typographie Tolmer, 1882.

Locke, Nancy. *Manet and the Family Romance*. Princeton, NJ: Princeton University Press, 2003.

Manet, Édouard, and Françoise Cachin. *Manet, lettres à Isabelle, Méry et autres dames*. Paris: Arts et métiers graphiques, 1985.

McGrady, Patrick J., Nancy Locke, and George L. Mauner. *Manet and Friends: An Exhibition of Prints Organized in Memory of George Mauner*. University Park, PA: Palmer Museum of Art, 2008.

Proust, Antonin. "Le Salon de 1882." *Gazette des Beaux-Arts* 25 (June 1, 1882): 533–54.

Reff, Theodore. *Manet, Olympia*. New York: Viking, 1976.

Waldmann, Emil. "Französische Bilder in amerikanischem Privatbesitz, I," *Kunst und Künstler* 9, no. 2 (1911): 85–97.

GAUGUIN

Allan, Scott. "'A Pretty Piece of Painting': Gauguin's *Arii Matamoe*." *Getty Research Journal*, no. 4 (2012): 75–90.

Bodelsen, Merete. "Gauguin, the Collector." *Burlington Magazine* 112, no. 810 (September 1970): 605–6.

———. "Gauguin's Cézannes." *Burlington Magazine* 104, no. 710 (May 1962): 204–11.

———. "The Wildenstein-Cogniat Gauguin Catalogue." *Burlington Magazine* 108, no. 754 (January 1966): 27–39.

Brettell, Richard R., and Anne-Birgitte Fonsmark. *Gauguin and Impressionism*. Exhibition catalogue. New Haven, CT: Yale University Press, 2005.

Brettell, Richard R., et al. *The Art of Paul Gauguin*. Exhibition catalogue. Chicago: Art Institute of Chicago; Washington, DC: National Gallery of Art, 1988.

Cahn, Isabelle. *Gauguin écrivain: Noa Noa, diverses choses, ancien culte maorie*. Paris: Réunion des musées nationaux, 2003. CD-ROM.

Carminati, Pauline. "Les momies du Muséum national d'histoire naturelle: Du cabinet anthropologique au Musée de l'homme." *La Lettre de l'OCIM*, no. 137 (2011): 26–34.

Danielsson, Bengt. *Gauguin in the South Seas*. New York: Doubleday, 1966.

———. "Gauguin's Tahitian Titles." *Burlington Magazine* 109, no. 769 (April 1967): 228–33.

Fontanieu, Guillaume. "La restitution des mémoires: Une expérience humaine, une aventure juridique." *Le Journal de la Société des Océanistes*, nos. 136/37 (2013): 103–18.

Gagné, Natacha. "Affirmation et décolonisation: La cérémonie de rapatriement par la France des *toi moko* à la Nouvelle-Zélande en perspective." *Le Journal de la Société des Océanistes*, no. 134 (2012): 5–24.

Gamboni, Dario. *Paul Gauguin: The Mysterious Centre of Thought*. Translated by Chris Miller. London: Reaktion, 2014.

Gauguin, Paul. *Ancien culte mahorie*. 1892. Reprint. Paris: La Palme, 1951.

———. *Avant et après* (January–February 1903). Facsimile. Copenhagen: Scripta/Paul Carit Andersen; S.A. J. Chr. Sørensen et Cie.; Fondation Ny Carlsberg, 1926.

———. *Avant et après* (January–February 1903). Reprint. Paris: Les Éditions G. Crès & Cie. 1923.

———. *Cahier pour Aline* (1893). Facsimile. Paris: Société des Amis de la Bibliothèque d'Art et d'Archéologie et William Blake & Co., Éditeur, 1989.

———. *Lettres à André Fontainas*. Paris: L'Échoppe, 1994.

———. *Lettres de Gauguin à sa femme et à ses amis*. Edited by Maurice Malingue. Paris: Grasset, 1946.

———. *Lettres de Paul Gauguin à Georges Daniel de Monfreid*. Edited by Victor Segalen. Paris: Librairie Plon, 1930.

———. *Noa Noa: Gauguin's Tahiti*. Edited by Nicholas Wadley. Translated by Jonathan Griffin. Oxford: Phaidon, 1985.

———. *Noanoa: Voyage à Tahiti* (1893–94). Facsimile. Stockholm: Jan Förlag for AB C. E. Fritzes Hovbokhandel, 1947.

———. *Noanoa: Voyage de Tahiti*. Facsimile. Paris: Musée d'Orsay/Réunion des Musées Nationaux, 2017.

———. "Qui trompe-t-on ici?" *Moderniste illustré* (Paris) 1, no. 22 (September 21, 1889): 170–71.

———. *Racontars de rapin: Facsimilé du manuscrit de Paul Gauguin, édition enrichie de dix-huit monotypes* (September 1902). Facsimile. Taravao, Tahiti: Éditions Avant et Après, 1994.

Groom, Gloria Lynn. *Gauguin: Artist as Alchemist*. Exhibition catalogue. Chicago: Art Institute of Chicago; Paris: Grand-Palais; New Haven, CT: Yale University Press, 2017.

Groom, Gloria Lynn, et al. *Gauguin: Paintings, Sculpture, and Graphic Works at the Art Institute of Chicago*. 2016. https://publications.artic.edu/gauguin/reader/gauguinart/section/139805.

Hamy, Ernest-Théodore. *Galerie américaine du musée d'ethnographie du Trocadéro: Choix de pièces archéologiques et ethnographiques décrites et publiées par le Dr E.-T. Hamy*. Paris: E. Leroux, 1897.

———. *Les origines du Musée d'ethnographie: Histoire et documents*. Paris: Leroux, 1890.

Jaussen, Tepano. *Grammaire et dictionnaire de la langue maorie: Dialecte tahitien*. Paris: Neia i te nenei raa no Belin, 1898.

Loti, Pierre. *Le mariage de Loti*. 2nd ed. Paris: Calmann Lévy, 1880.

Moerenhout, J. A. *Voyages aux îles du grand océan*. 2 vols. Paris: Arthus Bertrand, 1837.

Peltier, Philippe, and Magali Mélandri. "Chronologie concernant les têtes tatouées et momifiées māori ou *toi moko* (aussi connues sous le terme de *moko mokaï*)." *Le Journal de la Société des Océanistes*, no. 134 (2012): 28–30.

"Restitution des restes humains: Table ronde au festival de cinéma *Rochefort Pacifique*." *Le Journal de la Société des Océanistes*, nos. 136/37 (2013): 89–102.

Robley, Horatio Gordon. *Maori Tattooing*. London: Chapman and Hall, 1896.

Saussol, Alain. "En marge de l'insurrection Kanak de 1878: Nos 'fidèles alliés Canala,' mythe ou réalité?" *Le Journal de la Société des Océanistes*, nos. 136/37 (2013): 169–80.

Segalen, Victor. "Gauguin dans son dernier décor." In *Mercure de France*, 50, no. 174 (June 1904): 679–85.

———. *Les immémoriaux*. Paris: Les Éditions G. Crès et Cie., 1921.

Shackelford, George T. M., Claire Frèches-Thory, and Paul Gauguin. *Gauguin Tahiti*. Exhibition catalogue. Boston: Museum of Fine Arts, Boston, 2004.

Société d'Anthropologie de Paris. "Têtes de deux Néo-Calédoniens (Ataï et le sorcier)." *Bulletins de la Société d'Anthropologie de Paris*, October 23, 1879, 616–18.

Tardieu, Eugène. "La peinture et les peintres: M. Paul Gauguin." *L'écho de Paris*, May 13, 1895.

Thomson, Belinda, ed., with consultant editor Tamar Garb. *Gauguin: Maker of Myth*. Exhibition catalogue. Princeton, NJ: Princeton University Press, 2010.

Wildenstein, Georges. *Gauguin*. Paris: Les Beaux-Arts, 1964.

CÉZANNE

Amory, Dita, et al. *Madame Cézanne*. Exhibition catalogue. New Haven, CT: Yale University Press, 2014.

Athanassoglou-Kallmyer, Nina Maria. *Cézanne and Provence: The Painter in His Culture*. Chicago: University of Chicago Press, 2003.

Bernard, Émile. *Souvenirs sur Paul Cézanne et lettres*. Paris: À la Rénovation Esthétique, 1921.

Cachin, Françoise, Isabelle Cahn, and Walter Feilchenfeldt. *Cézanne*. New York: Abrams, 1996.

Cachin, Françoise, and Philippe Cézanne. *Atelier Cézanne: 1902–2002, le centenaire*. Arles, France: Actes sud; Aix-en-Provence, France: Société Paul Cezanne, 2002.

Cachin, Françoise, Philip Conisbee, and Denis Coutagne. *Cézanne and Paris*. Exhibition catalogue. Paris: Éditions de la RMN-Grand Palais, 2011.

Cachin, Françoise, and Phyllis Tuchman. "Cézanne." *Art Journal* 55, no. 4 (1996): 95.

Cahn, Isabelle. *Paul Cézanne: A Life in Art*. London: Cassell, 1995.

Cézanne, Paul. *The Letters of Paul Cézanne*. Edited and translated by Alex Danchev. London: Thames and Hudson, 2013.

Conisbee, Philip, Paul Cézanne, and Denis Coutagne. *Cézanne in Provence*. Washington, DC: National Gallery of Art, 2006.

Danchev, Alex. *Cézanne: A Life*. London: Profile Books, 2012.

Doran, Michael, Richard Shiff, and Lawrence Gowing. *Conversations with Cézanne*. Berkeley: University of California Press, 2001.

Elderfield, John, et al. *Cézanne Portraits*. Exhibition catalogue. London: National Portrait Gallery, 2017.

Fry, Roger. *Cézanne: A Study of His Development*. Chicago: University of Chicago Press, 1989.

Gasquet, Joachim. *Cézanne*. New York: E. Weyhe, 1926.

———. *Joachim Gasquet's* Cézanne: *A Memoir with Conversations*. Translated by Christopher Pemberton. London: Thames and Hudson, 1991.

Gouirand, André. *Les peintres provençaux*. Paris: Librairie Paul Ollendorff, 1901.

Haldemann, Anita, et al. *The Hidden Cézanne: From Sketchbook to Canvas*. New York and London: Prestel, 2017.

Kear, Jon. *Paul Cézanne*. London: Reaktion, 2016.

———. "Le sang Provençal: Joachim Gasquet's Cézanne." *Journal of European Studies*, no. 32 (2002): 135–50.

Pissarro, Joachim. *Pioneering Modern Painting: Cézanne and Pissarro, 1865–1885*. Exhibition catalogue. New York: Museum of Modern Art, 2006.

Platzman, Steven. *Cézanne: The Self-Portraits*. London: Thames and Hudson, 2001.

Reff, Theodore. "Cézanne and Poussin." *Journal of the Warburg and Courtauld Institutes* 23, nos. 1/2 (January–June 1960): 150–74.

———. "Cézanne's Drawings, 1875–85." *Burlington Magazine* 101, no. 674 (May 1959): 170–76.

Reff, Theodore, et al. *Cézanne: The Late Work*. Exhibition catalogue. London: Thames and Hudson, 1978.

Rewald, John. *Cézanne: A Biography*. New York: Harry N. Abrams, 1986.

Robaut, Alfred. *L'œuvre de Corot: Catalogue raisonné et illustré*. 4 vols. Paris: H. Floury, 1905. See III: 61–63, nos. 1422, 1431.

Rosenblum, Robert, and Françoise Cachin. *Paintings in the Musée d'Orsay*. New York: Harry N. Abrams, 1989.

Schapiro, Meyer. *Paul Cézanne*. New York: Harry N. Abrams, 1952.

Shiff, Richard. *Cézanne and the End of Impressionism: A Study of the Theory, Technique, and Critical Evaluation of Modern Art*. Chicago: University of Chicago Press, 1984.

———. "Distractions: Cézanne in a Sketchbook." *Master Drawings*. 47, no. 4 (Winter 2009): 447–51.

———. *Paul Cézanne*. New York: St. Martin's, 1994.

Shiff, Richard, et al. *The World Is an Apple: The Still Lifes of Paul Cézanne*. Hamilton, Ontario: Art Gallery of Hamilton, 2014.

Tate Gallery, Elizabeth Cowling, and Jennifer Mundy. *On Classic Ground: Picasso, Léger, De Chirico and the New Classicism, 1910–1930*. London: Tate Gallery, 1990.

Tuchman, Phyllis. "The Radical Classicist." *Art Journal* 55, no. 4 (1996): 95–97.

Vollard, Ambroise. *Paul Cézanne*. Paris: Galerie A. Vollard, 1914.

AFTERTHOUGHTS

Scofield Thayer, quoted in Jed Perl, "The Universal Eye." *New York Review of Books* 65, no. 13 (August 16, 2018): 76.

INDEX